Oil Painting Step by Step

with Anita Hampton, John Loughlin,
Tom Swimm, and Caroline Zimmermann

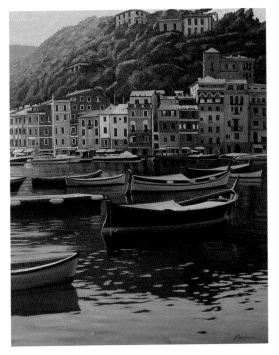

Soft Harbor Light by Tom Swimm

Contents

Oil Painting

The rich, versatile art of oil painting has captivated artists for centuries and continues to be one of the most favored painting mediums. Oil paints first became popular during the Renaissance, replacing sticky, fast-drying tempera paints as the prevalent medium. In contrast to tempera, oil paints dried slowly, which allowed the artist to mix colors directly on a support and to work on several different areas of a painting at once—techniques that are still widely used in oil painting today.

Oil is a very adaptable medium that lends itself to many painting styles—from the precision of photorealism to the freedom of expressionism. There is no single "correct" technique for painting in oil. As you experiment with this flexible art form, you'll find you can apply oil paints thickly, layer them on the canvas in a series of opaque glazes, and use a wide variety of painting techniques and approaches. You need only practice and desire to find out how easy, forgiving, and fun painting with oils can be!

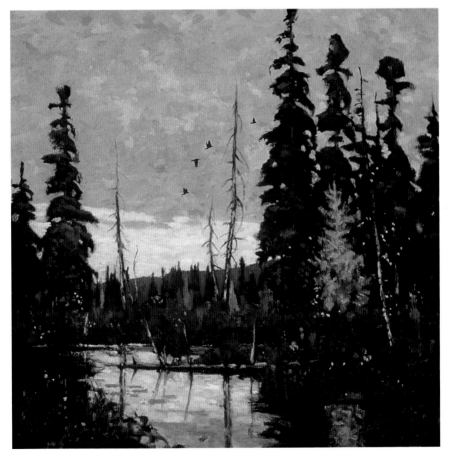

Yellowstone Autumn by John Loughlin

Tools & Materials

Going to the art supply store can be both exciting and a little overwhelming because there are so many supplies to choose from—at such a wide range of prices! It is important to buy the best quality you can afford. Higher-quality products last longer and produce better results than "budget brands." The next few pages cover the basics, but for more information, refer to *Oil Painting Materials* by William F. Powell in Walter Foster's Artist's Library series.

Oil Paints

Oil paints are available in two distinctive qualities: artists' grade and students' grade. Stick with artists' grade; they contain better-quality pigments and fewer additives. It's worth the extra money to obtain the more intense, longer-lasting colors of artists' grade oil paints. You don't need to purchase every color you see; you can mix just about any color from just a few, such as the colors suggested in the beginner's palette shown at right. You can always add to this palette later as your skills develop—and your budget allows! Keep in mind that colors vary slightly from brand to brand, so experiment with a few different manufacturers to find which ones you like best.

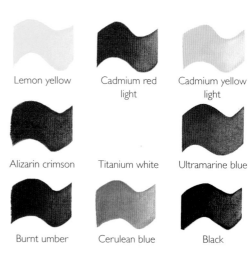

Lemon yellow | Cadmium red light | Cadmium yellow light

Alizarin crimson | Titanium white | Ultramarine blue

Burnt umber | Cerulean blue | Black

Basic Palette Each artist develops his or her own favorite palette of colors—and you will, too, with practice. The nine colors shown above provide a good basic palette to get you started.

Adding to the Palette

For the lessons in this book, you'll need to add the colors listed below to your basic palette. (Refer to each project for a complete listing of colors needed.)

❏ cadmium orange
❏ cadmium yellow medium
❏ cadmium yellow deep
❏ Naples yellow lt.
❏ yellow ochre
❏ burnt sienna

❏ quinacridone rose
❏ cadmium red medium
❏ phthalocyanine ("phthalo") blue
❏ cobalt blue
❏ viridian green
❏ sap green

Supports

The surface you paint on is called the "support." You can apply oils to just about any kind of support—canvas, glass, wood, cardboard, paper, even metal. You just need to apply a *primer* (such as polymer gesso) to give the oils something to stick to and to prevent the paint from shrinking, peeling, or cracking. Ready-to-use canvases are either mounted on heavy cardboard or prestretched and stapled to wood frames, and they are available in a variety of sizes and textures. The texture—called the "tooth"—can range from a fine, dense weave (which is smooth) to a coarse, loose weave (which is rougher and so has more texture).

Paintbrushes

Oil paintbrushes are made with either natural or synthetic hair or bristles and come in a wide variety of styles and sizes. Hake and fan brushes are designed for making soft blends. Liners are suited for fine detail work. Soft-hair flats are great for long, soft blends and strokes. Soft-hair rounds hold a point, and they allow you to vary the widths of your brushstrokes. Brights have shorter bristles, making them good for more aggressive brushwork. Stiff, bristle-hair filberts are flat brushes with slightly rounded tips and are good for applying a lot of paint and for creating texture. (You may want to start out with three filberts: small, medium, and large.)

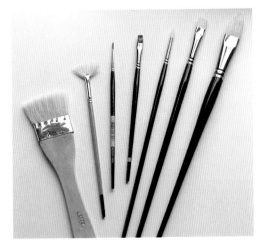

Starter Set These seven brushes are all you need to get started painting in oil (from left): hake, fan, liner (also called a "rigger"), soft-hair flat, soft-hair round, medium-size bright, and bristle filbert.

Brush Care

Good brushes are expensive, but if you take care of them, they can last for several years. Never allow paint to dry in the hair or bristles; oil is destructive and tends to cling deeply in the bristles next to the ferrule (the metal band). Wash your brushes thoroughly after each painting session, first with thinner (such as turpentine or mineral spirits), then with soap and warm (but not hot!) water.

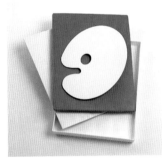

Palettes When selecting a palette, make sure it's large enough for mixing all the colors you want to use.

Mixing Palettes

A palette is used for laying out colors and for mixing colors. They're available in various shapes, sizes, and materials— from ceramic and plastic to metal and glass. When you're done painting, clean your palette and be sure to scrape off any mixed paint. (It's a good idea to always place your colors in the same order on your palette; this way, you won't waste time searching for the color you want.)

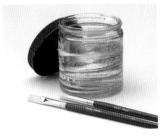

Coil Jar Coil jars, available at art stores, are used to clean your brushes. Fill the jar with thinner and rub your brush against the coils to loosen the paint from the bristles.

Palette Knives

Palette knives are ideal for mixing colors on the palette, but they can also be used to apply paint to the support. Palette knives are gently rounded, whereas painting knives are narrower and more pointed, with more flexible tips. Available in diamond, pear, and trowel shapes, knives are useful for scraping away paint, creating textures, and blending large areas on the canvas.

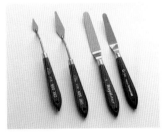

Knives The knives on the left are painting knives; those on the right are palette knives. The steep angle in the neck of painting knives keeps your hand from getting in the paint.

5

Setting Up a Work Station

Make sure you have a well-lit work area. Many artists prefer working under natural light from a window, but artificial light is necessary for painting at night. (Most lamps can be fitted with blue "daylight simulation" bulbs.) Oil paints and solvents have strong fumes and some are toxic, so be sure your space is well ventilated. Your easel selection should be based on where you paint and what size supports you plan to use; there is a wide variety of tabletop or stand-alone easels from which to choose. Finally, don't forget a comfortable chair!

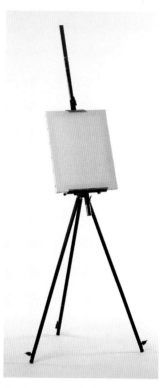

Easel If you have limited space in which to paint, choose a compact, collapsible easel like this one.

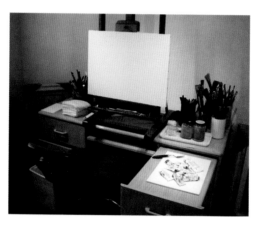

Your Work Space When painting indoors, you'll need plenty of space so you can keep all your painting materials within easy reach.

Collecting References

Although painting from life is ideal, it isn't always practical. Keep a reference file (often called an "artist's morgue") of things you're interested in painting. Use a scrapbook, an envelope, file folders, or a shoebox to start collecting postcards, photographs, clippings from magazines—anything you'd like to include in your oil paintings or refer to for inspiration.

Organizing References You may want to keep your references organized by subject, such as people, animals, landscapes, trees, flowers, and so on.

Basic Supplies

Below is a list of the materials you'll need to purchase to get started painting in oils. (For specifics, refer to the suggested brushes and colors on pages 4–5).

❏ Paintbrushes
❏ 8 oil colors
❏ Painting supports
❏ Easel
❏ Mixing palette
❏ Palette knife
❏ Medium (linseed oil, copal)
❏ Thinner (mineral spirits, turpentine)
❏ Containers for additives
❏ Rags or paper towels

Preparing Your Own Support

It's economical and easy to prime your own supports. Gesso—a polymer product with the same base ingredients as acrylic paint—is a great coating material because it primes and seals at once. It's also fast-drying and is available at any art supply store. Use a standard 1/8" pressed-wood panel from the lumber store, and sandpaper its surface until the shine is gone. Then apply two or three coats of gesso, sanding the surface in between coats and using both horizontal and vertical strokes for even coverage and to give the surface some texture.

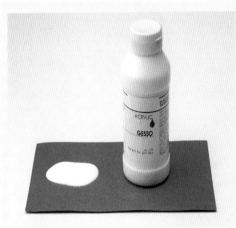

Applying Gesso Gesso is usually white, but is also available in other colors. Apply gesso directly to your support with a brush, a palette knife, a spatula, or any large, flat application tool.

Using Additives

Most oil painters use additives (such as mediums and thinners) to change the paint consistency. For the projects in this book, we recommend using additives primarily to thin the paint, but many artists apply trans-parent glazes of mediums to expedite the paint's drying time. Linseed oil is the most popular medium, while turpentine and min-eral spirits are common solvents.

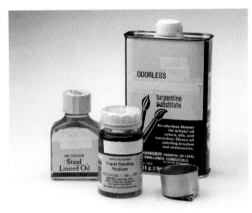

Choosing Mediums Each additive does something a little different. Linseed oil gives paints a buttery, glossy, more transparent quality, while turpentine dilutes oil paints to a thin, workable consistency. Both of these additives make oil paints easier to apply and blend.

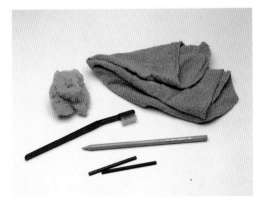

Extras There are a variety of helpful tools that you can use to blend colors directly on your support. Toothbrushes, paper towels, and natural sponges are some of the most common blending tools.

Additional Materials

In addition to the essentials, there are sev-eral extra items that you may want to pur-chase to make your work sessions easier. Pencils or charcoal for drawing, glass or metal cups for your mediums, and a paint box with a lot of compartments are all handy items to have.

Color Theory and Mixing

Knowing a little about color theory will help you tremendously in mixing colors. All colors are derived from just three *primary* colors—red, yellow, and blue. (The primaries can't be created by mixing other colors.) *Secondary* colors (orange, green, purple) are each a combination of two primaries, and *tertiary* colors (red-orange, red-purple, yellow-orange, yellow-green, blue-green, blue-purple) are the results of mixing a primary with a secondary. *Hue* refers to the color itself, such as red or green, and *intensity* means the strength of a color, from its pure state (straight from the tube) to one that is grayed or diluted. *Value* refers to the relative lightness or darkness of a color. (By varying the values of your colors, you can create depth and form in your paintings.)

Color Wheel

A *color wheel* (or *pigment wheel*) is a useful reference tool for understanding color relationships. Knowing where each color lies on the wheel makes it easy to understand how colors relate to and react with one another. Whether they're opposite one another or next to one another will determine how they react in a painting—which is an important part of evoking mood in your paintings. (See the following sections on color psychology and complements versus analogous colors.)

Color Psychology

Colors are referred to in terms of "temperature," but that doesn't mean actual heat. An easy way to understand color temperature is to think of the color wheel as divided into two halves: The colors on the red side are warm, while the colors on the blue side are cool. As such, colors with red or yellow in them appear warmer. For example, if a normally cool color (like green) has more yellow added to it, it will appear warmer; and if a warm color (like red) has a little more blue, it will seem cooler. Temperature also affects the feelings colors arouse: Warm colors generally convey energy and excitement, whereas cooler colors usually evoke peace and calm. This explains why bright reds and yellows are used in many children's play areas and greens and blues are used in schools and hospitals.

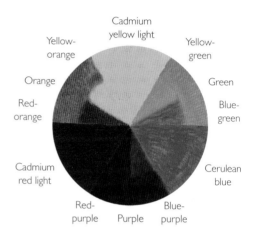

Warm Color Wheel The color wheel above shows a range of colors mixed from warm primaries. Here you can see that cadmium yellow light and cerulean blue have more red in them (and that cadmium red has more yellow) than their cool counterparts in the wheel below do.

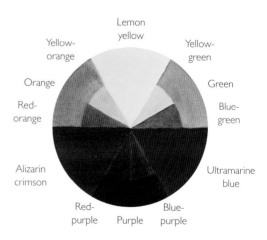

Cool Color Wheel This cool color wheel shows a range of cool versions of the primaries, as well as the cool secondaries and tertiaries that result when they are mixed.

Complementary and Analogous Colors

Complementary colors are any two colors directly across from each other on the color wheel (such as purple and yellow). When placed next to each another in a painting, complementary colors create lively, exciting contrasts, as you can see in the examples at right. *Analogous* colors are those that are adjacent to one another (for example, yellow, yellow-orange, and orange). And because analogous colors are similar, they create a sense of unity or color harmony when used together in a painting.

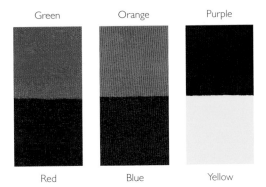

Complementary Colors Here are three examples of complementary pairs. Using a complementary color in the background will cause your subject to seem to "pop" off the canvas. For example, place bright orange poppies against a blue sky, or enliven some yellow sunflowers by placing them in a purple vase.

Mixing Neutrals

There are very few pure colors in nature, so it's important to learn how to neutralize your oil colors. Direct complements can "gray" each other better than any other colors. For example, mixing equal amounts of two complementary colors results in a natural, neutral gray. Or to simply mute a color, making it more subtle and less vibrant, just mix in a bit of its complement. But there are so many neutrals that you'll need to go beyond using only complements. The chart below shows how to create a range of grays and browns using colors from the basic palette on page 4.

1 part ultra. blue +	1 part burnt umber	3 parts ultra. blue 1 part burnt umber	+ 2 parts white	1 part ultra. blue 2 parts burnt umber	+ 1-1/2 parts white	3 parts ultra. blue 1 part burnt umber 2 parts cadmium red lt.	1 part ultra. blue 1 part burnt umber 2 parts cadmium yellow lt. 2-1/2 parts white

1 part alizarin crimson +	1 part ultra. blue =	Purple mixture	1-1/2 parts alizarin crimson 1 part ultra. blue 1 part cadmium yellow lt.	+ 1-1/2 parts white	1 part alizarin crimson 1 part ultra. blue 1 part lemon yellow	+ 1-1/2 parts white	1 part alizarin crimson 1 part burnt umber 2 parts cadmium yellow lt.	2 parts alizarin crimson 1 part burnt umber 1 part lemon yellow

Experimenting with Color Mixes

You can mix just about any color from a few basic tubes of oil paint. Many beginning artists feel as though they have to buy every shade of paint available to them at the art supply store, but by learning a few simple mixing "strategies," you can mix your own fresh, lively colors. In fact, try to keep your palette simple to avoid overblending, which makes colors less fresh and muddy looking. Knowing how to mix your own colors is a liberating and economical skill. The chart below demonstrates the wide variety of colors you can mix from only the basic beginner's palette (see page 4). Although the artists in this book use different palettes, refer to this chart to create comparable colors, or make your own chart.

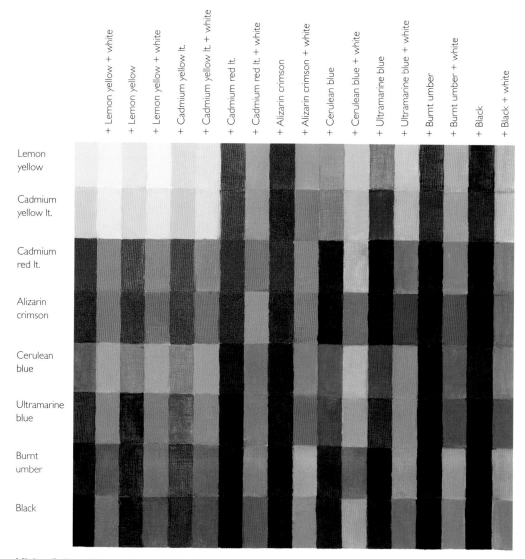

Mixing Colors Notice that several of the above color combinations create black. Many oil painters prefer to mix their own blacks with colors from their palette, as they feel the resulting black mixtures are fresher than black tube paints.

Tinting and Shading

You can also mix a great range of values by simply adding white to a color (creating a *tint* of that color) or by adding black (creating a *shade* of that color). The chart below demonstrates some of the tints and shades you can create by adding varying amounts of white or black to a pure color. To avoid mixing muddied colors, here are some simple tips: When adding white to any color, also add a touch of the color *above* it on the color wheel (see page 8). For example, when you add white to red, also add a tiny bit of orange. This creates a more fresh and lively tint. When adding black to any color, also add a touch of the color *below* it on the color wheel. For example, when you add black to green, also add a small amount of blue-green, which makes a richer and more vibrant shade.

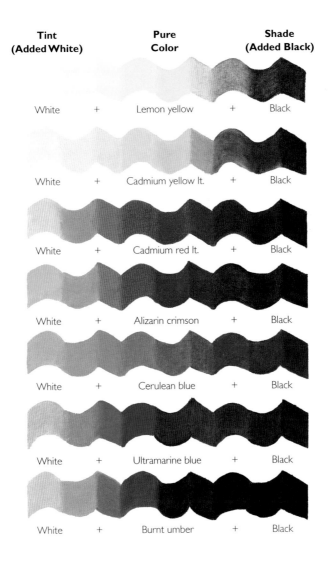

Tint (Added White)		Pure Color		Shade (Added Black)
White	+	Lemon yellow	+	Black
White	+	Cadmium yellow lt.	+	Black
White	+	Cadmium red lt.	+	Black
White	+	Alizarin crimson	+	Black
White	+	Cerulean blue	+	Black
White	+	Ultramarine blue	+	Black
White	+	Burnt umber	+	Black

Diluting and Toning Another method for lightening your colors is to dilute the color with a solvent, such as turpentine. You can also add gray to a color, creating a *tone* of that color.

Basic Oil-Painting Techniques

Most oil painters apply paint to their supports with brushes. The variety of effects you can achieve—depending on your brush selections and your techniques—is virtually limitless. Just keep experimenting to find out what works best for you. A few of the approaches to oil painting and brushwork techniques are outlined below.

Approaching Your Painting

There are three basic approaches to oil painting; you may want to try each approach to see which you prefer. In the first approach, you begin by toning the entire canvas with a layer of transparent color (an *imprimatura*) and then build up the painting with a series of thin layers of color (*glazes*) on top of the initial color. For the second approach, you build the painting from dark to light or light to dark; for example, you may start by blocking in all the darkest values, then add the mid-values, and finish with the lightest values. The third approach is called *alla prima*, which is Italian for "at once." This means that you apply all the paint in a single painting session. In this approach, you are not applying a series of layers but laying in the opaque colors essentially the way they will appear in your final painting. Artists also refer to this method as a *direct approach*.

Painting Thickly Load your brush or knife with thick, opaque paint and apply it liberally to create texture.

Thin Paint Dilute your color with thinner, and use soft, even strokes to make transparent layers.

Drybrush Load a brush, wipe off excess paint, and lightly drag it over the surface to make irregular effects.

Blending Use a clean, dry hake or fan brush to *lightly* stroke over wet colors to make soft, gradual blends.

Glazing Apply a thin layer of transparent color over existing dry color. Let dry before applying another layer.

Pulling and Dragging Using pressure, pull or drag dry color over a surface to texturize or accent an area.

Stippling Using the tip of a brush or knife, apply thick paint in irregular masses of small dots to build color.

Scumbling Lightly brush semi-opaque color over dry paint, allowing the underlying colors to show through.

Scraping Use the tip of a knife to remove wet paint from your support and reveal the underlying color.

Wiping Away Wipe away paint with a paper towel or blot with newspaper to create subtle highlights.

Sponging Apply paint with a natural sponge to create mottled textures for subjects such as rocks or foliage.

Spatter Randomly apply specks of color on your canvas by flicking thin paint off the tip of your brush.

Painting with a Knife

With painting knives, you can apply thick textures or render intricate details. Use the side of your knife to apply paint thickly. Use the fine-point tip of your knife for blending and drawing details. Below are some examples of effects you can achieve with a painting knife.

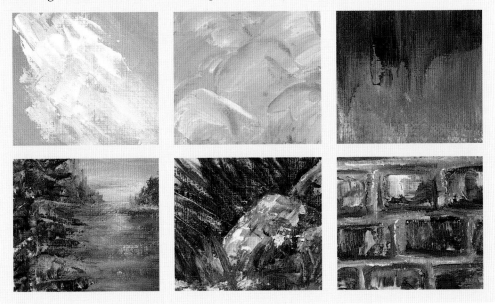

About the Artists

Anita Hampton

Anita Hampton has been painting for most of her life. Although she has studied under renowned instructors and at various colleges, she considers herself primarily self-taught. Anita is a signature member of the California Art Club and Laguna Plein Air Painters Association and a member of Oil Painters of America. Some of her recent shows and awards include the fol-

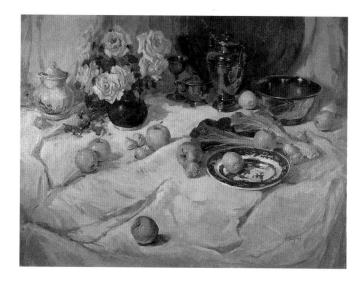

lowing: Anita was recently listed in *Who's Who in America* for accomplished achievements, and she won first place at the CAC and SJC Plein Air Painting Festivals in 2001. She also won first place at the 2001 Images of Crystal Cove Exhibition and was a Franklin Mint Award winner at the National Oil Painters of America Exhibition. Anita's work is featured in the American Embassy Plein Air Painting Exhibition in Madrid, Spain.

John Loughlin

John Loughlin is a New England artist whose work includes oil paintings, watercolor paintings, drawings, and fine art prints. Specializing in capturing the natural beauty of the New England countryside, John's work is included in many corporate and private collections throughout the East Coast and nationally. John is a member of the Guild of Boston Artists, and he recently won the Great Gatsby Memorial Award from the Rockport Art Association. He has won numerous other awards in regional and national exhibits, including a Medal of Honor for oil painting and election into the American Watercolor Society. John currently lives in Lincoln, Rhode Island.

Tom Swimm

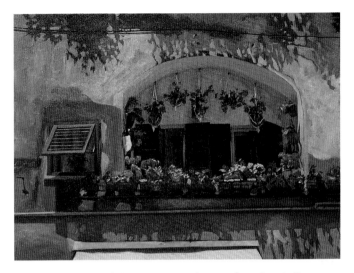

Since early childhood, Tom Swimm has felt an instinctive need to paint. Although he is self-taught, he has long been inspired by the work of Van Gogh, Monet, and Hopper, and he considers these masters his teachers. His passion for exploring color and various painting techniques has brought him many artistic rewards. To Tom, being an artist is about challenging himself to evolve creatively. Tom's first one-man exhibition was at the Pacific Edge Gallery in Laguna Beach, California. His work has also been featured in several other California galleries, ArtExpo New York, and the APPAF Exhibition in Paris, France. His paintings have appeared on the cover of Skyward Marketing's *In-flight Magazine* in 2001, as well as on the cover of *Artist's Magazine* in 1992. Tom won the People's Choice award at Echoes and Visions in 1997 and the Art of California Gold Award in 1994. Born in Miami, Florida, and raised in New York, Tom currently resides in San Clemente, California.

Caroline Zimmermann

Caroline Zimmermann began painting in oils at age 6, earned her Bachelor of Fine Arts in Illustration from California State University, Fullerton in 1989, and obtained her Master of Fine Arts in Painting from the California College of the Arts and Crafts in Oakland in 1994. She currently resides in the artists' community of Laguna Beach, where she has lived, surfed, and painted for more than 18 years. Caroline travels extensively and enjoys painting abroad, most notably in Italy. She has exhibited at the Laguna Beach Festival of the Arts for 15 years. Her work is featured in galleries in Laguna Beach, as well as in Mono County in the Sierras, Sonoma, and Mammoth Lakes.

Lesson 1: Toning Your Support
with John Loughlin

Many artists start painting by toning the entire canvas with a mid-value wash, called an *underpainting* or *undercolor*. An underpainting is just as it sounds—"under the painting"; it's meant to be painted over. Think of this base color as a warm-up exercise, but remember that the subsequent colors you apply will interact with the hue of the underpainting. So if your subject has a lot of warm colors, you may want to apply a warm undercolor; conversely, a subject with cool hues can be accentuated with a cool undercolor. For this cool snow scene, artist John Loughlin applied a cool, mid-value wash to the entire canvas before sketching his subject with soft vine charcoal.

Color Palette

alizarin purple*, black, burnt sienna, cadmium orange, cerulean blue, chromium oxide green*, cobalt violet*, Mars violet*, Naples yellow light, titanium white, yellow ochre

* Colors marked with an asterisk are not listed in the basic palettes on page 4.

Step One I begin with a mixture of Mars violet and black thinned with turpentine to tone the entire canvas, making sure I achieve a balanced mid-value hue overall. (If the undercolor is too dark, subsequent dark-value colors won't appear dark enough in contrast; if it is too light, subsequent light-value applications won't read well.) After the wash is dry, I sketch the composition over it. I concentrate on blocking in the areas with the lightest highlights as well as the darkest shadows.

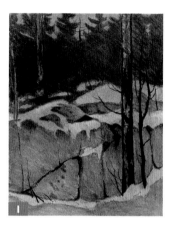

Undercolor

black, Mars violet, and turpentine

Step Two Using a round brush and a thicker version of the undercolor mixture, I block in the basic shapes of the rocks. Then I use a small filbert bristle brush to block in the dark woods, thoroughly shading the entire area. I also indicate the dark areas of the large tree on the right and some shadows on the underside of the rocks. Next I paint the sky between the trees with a mix of cerulean blue and white. Using the same cerulean blue and white mixture, I add a few small patches of snow in the dark wooded area.

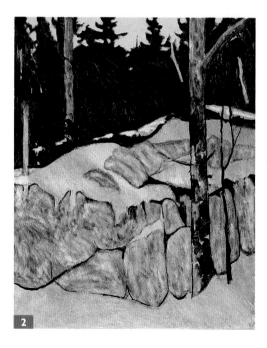

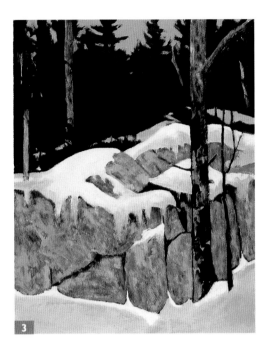

Step Three After painting in New England for many years, I've learned that snow is never actually white. It always reflects other hues, and it changes in value depending on where it's illuminated and shadowed. Here I paint the snow on the rocks and in the foreground using a mix of white, cerulean blue, and cobalt violet. I deepen the mix slightly for the foreground, as this area is shadowed by the rocks.

Snow

white, cerulean blue,
and cobalt violet

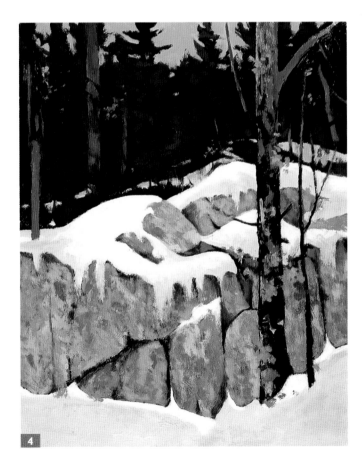

Step Four I develop the textures of the rocks, creating an overall mottled effect by mixing several different colors. I apply one mix of black and Naples yellow light and another mix of Naples yellow light and chromium oxide green, varying the direction of my brushstrokes to create a random, natural-looking blend of color and allowing small areas of the toned canvas to show through. I apply color to the darkest areas of the woods with mixes of alizarin purple, burnt sienna, and black, and I introduce some colorful foliage with a combination of cadmium orange, Naples yellow light, and burnt sienna.

Rocks

black and
Naples yellow
light

Naples yellow
light and
chromium
oxide green

17

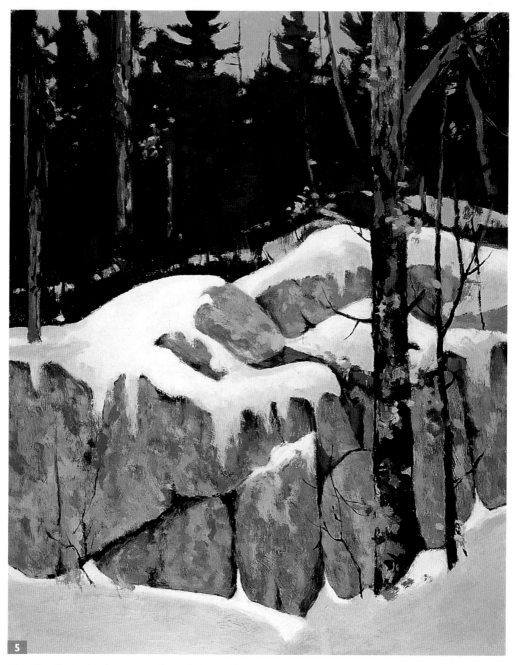

Step Five To develop the texture of the rocks, I use white to lighten the rock mixtures from step 4 and then apply the colors using short, choppy strokes. I leave areas of darker gray showing through here and there to emphasize the mottled color. I also add more yellow leaves throughout the composition. Then I retouch the sky and make it more colorful with additional touches of phthalo blue and white.

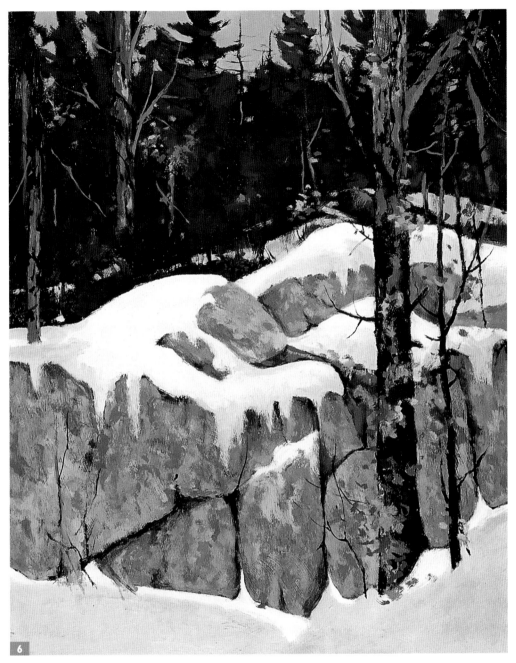

Step Six Now I step back from my painting so I can see where it needs more depth and detail. I decide to add some lighter branches to the trees using a mix of burnt sienna, black, and white. Then I highlight some of the trees with a light green mix of chromium oxide green and yellow ochre. Finally, I punch up the violets in the dark areas with a combination of cobalt violet, alizarin purple, and a little white.

Lesson 2: Finding a Focus
with John Loughlin

After choosing your subject, you need to determine the perspective, or *viewpoint*, from which you wish to paint a scene. Begin by looking at the scene and asking yourself which elements attract your eye. Pick the object that interests you the most and make that the *focal point* of your painting. There are several ways to bring the focus onto your subject. Cropping a scene (or "zooming in" on your subject) and choosing a format (horizontal, vertical, or square) that complements your subject are two excellent ways to accentuate your focal point. For example, for this painting of a beautiful grove of birch trees, artist John Loughlin was interested in the play of light and shadows on the tree trunks, so he cropped out the tops of the birches to keep the focus on the bark. He also chose a vertical format to accent the tall trees and to pull attention to the way the filtered sunlight fell on the white trunks.

Color Palette

alizarin crimson, black, burnt sienna, cadmium orange barium*, cadmium red light, cerulean blue, cobalt blue, cobalt violet*, Mars violet*, Naples yellow light, titanium white, viridian green, yellow ochre

Upper Third of Sky	**Middle Third of Sky**	**Lower Third of Sky**
cobalt blue, cobalt violet, and white	cobalt blue and white	Naples yellow light, viridian green, cerulean blue, and white

 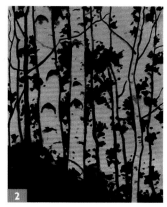 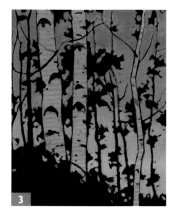

Step One I use a mix of Mars violet and black thinned with turpentine to tone the entire canvas. Once this underpainting is dry, I sketch the composition with soft vine charcoal, which allows me to erase and correct my composition as I draw.

Step Two I use a small round brush and a mix of black and Mars violet with very little turpentine to paint over the outlines of the birches. I also indicate the smaller branches of the other trees with quick, loose strokes. I then block in the dark leaf shapes and the darker areas of the foreground.

Step Three Now I block in the blues of the sky around the dark shapes. For the upper third, I use a mix of cobalt blue, cobalt violet, and a little white. For the middle third, I use a lighter mix of cobalt blue and white. For the lower third, I use a mix of Naples yellow light, viridian green, cerulean blue, and white.

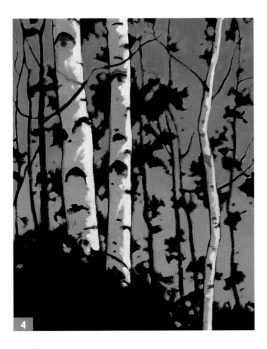

Step Four Now I'm ready to paint the lighter values—the highlights on the tree trunks. My light source is coming from the upper right, falling on the right side of the three trees in the foreground. I use Naples yellow light and white to cut into the right sides of the trees, painting choppy, irregular strokes to make the light look as though it's filtered through leaves and branches. I apply the paint thickly, using an *impasto* technique—painting thick applications of color to create the illusion of texture. I use impasto for the highlights because I want the paint to be more opaque and therefore true to bright, strong light in nature. Many artists like to create the rough, textured look of impasto with the flat side of a painting knife, but I find that my small filbert brush works well here.

Highlights

Naples yellow
light and white

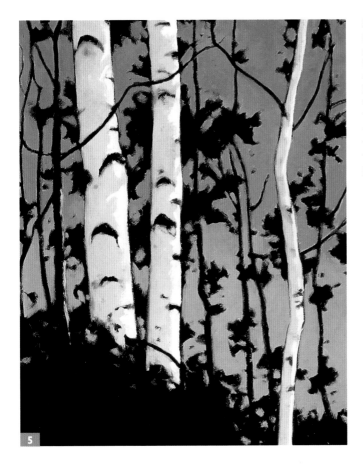

Step Five I don't wait for the thick paint of the highlights to dry before painting the shadowed side of the birches. Instead I blend the light and dark values with crisscrossing brushstrokes to create the natural, wavy, irregular appearance of light. With a mixture of cobalt blue, cobalt violet, and white, I add the shadows to the left sides of the three trees in the foreground, applying a lot less paint than I used for the light sides.

Shadows

cobalt blue,
cobalt violet, and
white

21

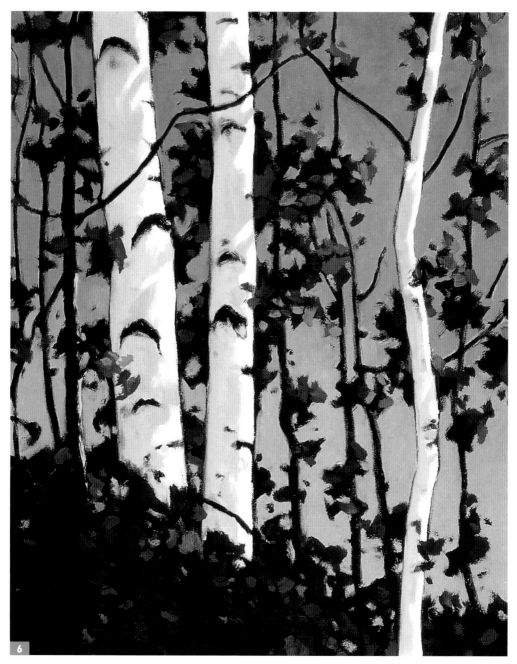

Step Six Once I've blocked in the strongest darks and lights, I'm ready to lay in the colors. I create several slightly varied mixtures of yellow ochre, Naples yellow light, cadmium orange barium, cadmium red light, and alizarin crimson. For the leaves at the bottom left and throughout the shadowed background, I create three darker mixtures—one with a little Mars violet, one with burnt sienna, and one with cobalt blue. Then for the highlighted leaves on the right and in the foreground, I progressively lighten the mix with Naples yellow light and white. I am continually changing my mixtures because I want to create a rich variety of values in the autumn foliage. This creates more depth in the painting.

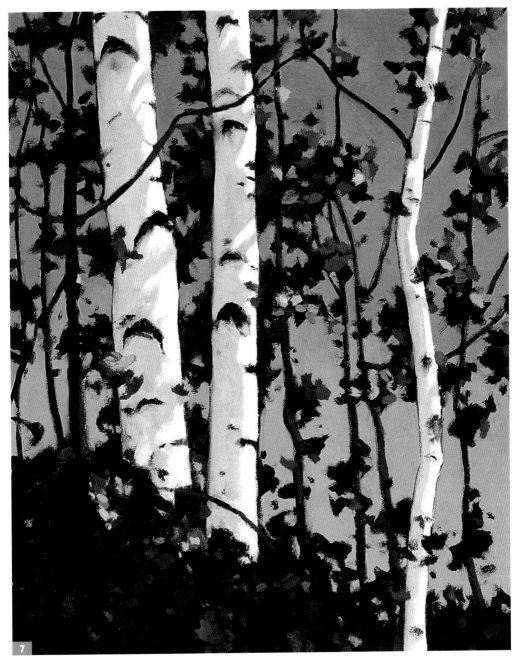

Step Seven Now I step back and evaluate the birches. I decide the light sides of these trees could use even more texture and that I want to add more warmth with a mixture of Naples yellow light and white. I also want to make the lighting a little more dramatic, so I darken the shadowed sides of the trees with a mixture of cobalt violet, cobalt blue, and a little white. As a final brightening touch, I add some light-colored leaves to a few of the trees and in the foreground. I make these lightest leaves a brilliant yellow that contrasts with the dark oranges and browns and enlivens the entire painting.

Lesson 3: Painting Outdoors
with John Loughlin

Painting from photographs is convenient, but nothing can compare to painting from life. When painting outdoors, the light changes quickly, affecting colors and cast shadows, so you need to focus on capturing the mood and recording the basic shapes of a scene. Don't try to render every detail; you don't even need to complete the entire painting on site. For example, for this painting of a New England seaside, artist John Loughlin concentrated on sketching the shapes of the clouds and the changes in value throughout the scene's dramatic skyline while he was on site. Then he filled in his outlines with various vibrant colors back in his studio.

Color Palette

black, burnt sienna, cadmium orange barium*, cerulean blue, cobalt blue, cobalt violet*, Mars violet*, Naples yellow light, phthalo blue, titanium white, viridian green, yellow ochre

Step One I begin by covering the canvas with a very light wash of cobalt blue and burnt sienna thinned with turpentine. I use vine charcoal pencil and approach my sketch as a basic outline for where I want to place the colors. I concentrate on capturing the areas where the values change throughout the sky, outlining the shapes of the clouds. Next I indicate the two distant lighthouses on the horizon. Then I block in the dark, large shapes in the landscape, lightly shading these areas with the side of the charcoal.

Dark Values

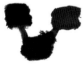

black and
Mars violet

Step Two Once I'm happy with my sketch, I retrace the outline of each shape with a small round brush and a thin mixture of black and Mars violet. Then I apply all my darkest values. At this stage, I'm still working on my underpainting, filling in the rocks in the foreground and the rest of the land in the distance. Even though the rocks appear to be pure black, I add Mars violet to the mixture to keep the color from becoming too inky and flat.

24

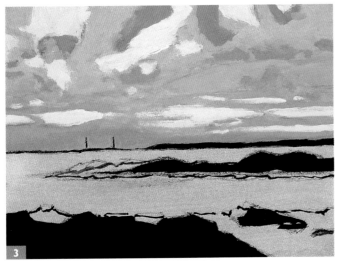

Upper Sky

cobalt blue and
cobalt violet

cobalt blue and
white

Lower Sky

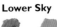

viridian green and
cerulean blue

Horizon

cobalt violet and white

Step Three Now I paint the sky with a mix of cobalt violet and white, stroking horizontally with a small filbert bristle brush. I mix cerulean blue, viridian green, and white for the lower patches of blue sky and create the brighter blue patches of the upper sky with cobalt blue, a very small amount of phthalo blue, and white. For the grays in the upper part of the sky, I mix cobalt violet and white. Then I block in the clouds with a mix of white and Naples yellow light.

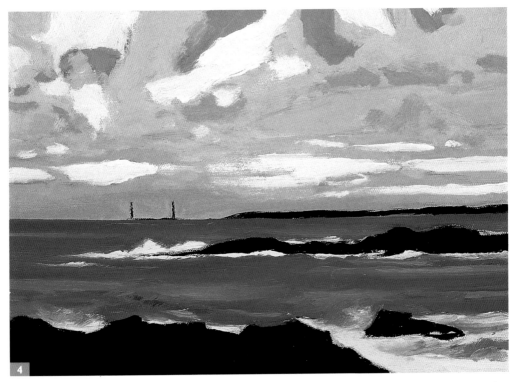

Step Four Now I block in the ocean, covering most of the water area with a mixture of viridian green, phthalo blue, and cobalt violet. I add a few dark patches of cobalt blue, cobalt violet, and viridian green. To suggest movement in the water, I add light blue streaks of a cobalt blue and white mixture. I paint the surf around the distant headland and foreground using pure white, varying between thick and thin brushstrokes to create a realistic impression of texture and motion in the tide.

Foreground Highlights

Naples yellow light and
yellow ochre

Distant Highlights

Naples yellow light and
cadmium orange barium

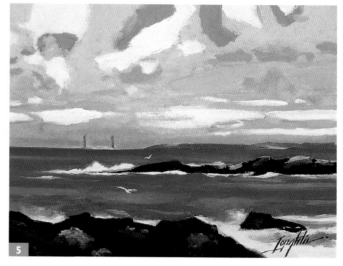

Step Five Now I add highlights and details to the rocks and distant land forms.
With a mixture of Naples yellow light and yellow ochre, I work in the lighter
textures of the foreground areas. Then I mix Naples yellow light and cadmium
orange barium for the highlights of the middle ground and the land in the
background. I lighten the farthest plane of land significantly to emphasize the sun's
high midday position and the illuminated horizon.

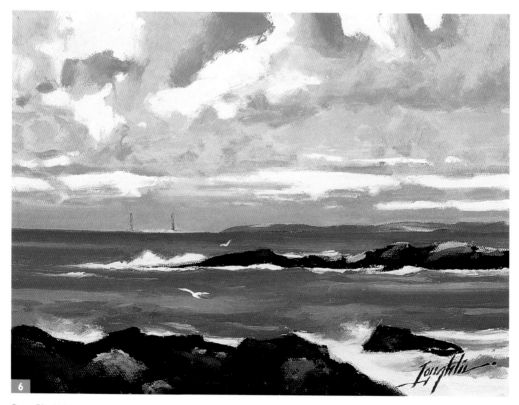

Step Six When I step back and assess the painting, I decide to adjust some of the colors. Although I'm happy with the colors
I chose in the sky, I want to sharpen the contrast by changing some of the values. I deepen the darkest values by adding more
pigment, and I add more white to the lightest values. I also decide some of the values in the ocean are too light and that the
surf needs to be brighter, so I add deeper shades of the ocean mixes and then brighten the surf with pure white.

26

Using a Viewfinder

When painting on location, a viewfinder can be an invaluable tool. Consisting of two L-shaped frames, a viewfinder helps you zero in on one section of a scene and block out any unnecessary elements. It also helps establish which format will make the most effective composition. You can buy one, make your own out of cardboard, or even use your thumbs and forefingers. Hold the viewfinder up and look through the opening at the scene in front of you. Bring it closer to you or hold it further away; turn it sideways and move it around. Then choose the view you like best.

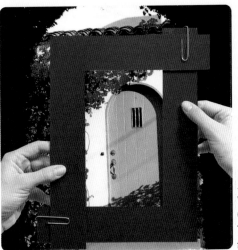

Photo by Tom Swimm

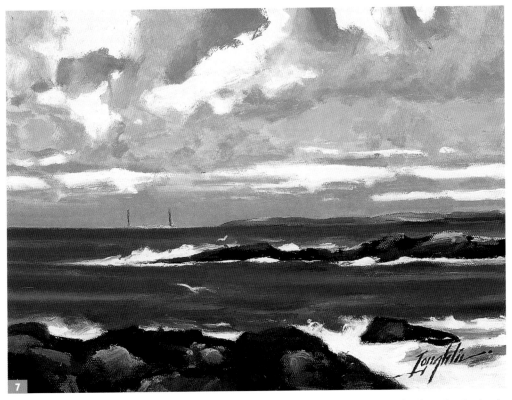

Step Seven For the finishing touches, I use my small bristle filbert to add a little more detail to the distant headland and in the foreground. For the details in the distance, I use Naples yellow light with a touch of cadmium orange. I mix Naples yellow light, yellow ochre, burnt sienna, and black and lightly brush on some final touches of texture to the foreground.

Lesson 4: Composing Dynamic Scenes
with Anita Hampton

When painting outside, many artists wish they could paint everything they see, but that wouldn't make a very dynamic composition. *Composition* is more than just the design or layout of a painting; it is the relationship among the elements in a painting. In a good composition, the various elements have an organized flow and work together to create a visual path that draws the viewer's eye to the painting's center of interest, or focal point. One of the easiest ways to create a visual path and a sense of movement in your paintings is to include curving lines that lead from the foreground into the middle of the composition. In this landscape, for example, artist Anita Hampton uses the water at the bottom to lead the viewer into the painting. Then the darks on the right pull the eye in a clockwise circle around the cloud and the tree, and back to the foliage at the bottom right. This kind of circular movement is called a "tunnel pattern," and it entices the viewer to visit all the areas of the canvas.

Color Palette

blue-violet*, burnt sienna, cadmium red light, cadmium yellow pale*, cerulean blue, cobalt blue, phthalo yellow-green*, quinacridone rose, titanium white, ultramarine blue, viridian green, yellow ochre

Sky

white

+ cad. yellow pale and viridian green

+ more viridian green

+ cerulean blue

+ ultra. blue

+ more ultra. blue

+ rose

Step One I sketch directly on my canvas with a small flat brush and a mix of viridian green, yellow ochre, and turpentine. Then I block in the largest light shape—the cloud formation to the left of the large tree—with a thick mix of white, a little cadmium yellow pale, and cadmium red light. I darken the sky with a gray mix of cobalt blue and cadmium red light, gradually adding more color with cobalt blue, cadmium red light, cerulean blue, and ultramarine blue. Then I cover the distant mountain range with a mix of white, ultramarine blue, quinacridone rose, and a touch of yellow ochre. I carry the color through the trees to the right of the canvas, so the mountains don't seem to drop off into space somewhere in the middle of the painting.

28

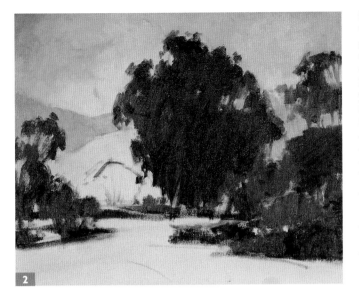

Step Two I create the dark foliage with a mix of ultramarine blue, viridian green, burnt sienna, and a little yellow ochre. I block in the center of interest (the large tree), warming the upper left where the light falls with more yellow ochre and a touch of cadmium red light. For the shadowed right side, I cool the mix with viridian green and a little burnt sienna. I adjust the mixes as I paint the outlying foliage, often changing the dominant dark color, so the foliage is made up of a variety of greens. This color variation is true to nature and makes a more realistic painting. As I paint the background trees at the top right, I allow some light color from the sky to mix with the dark paint and then I blend it with light, feathery strokes (but not too much, or the color will look chalky!).

Dark Tree Mass

Mountain

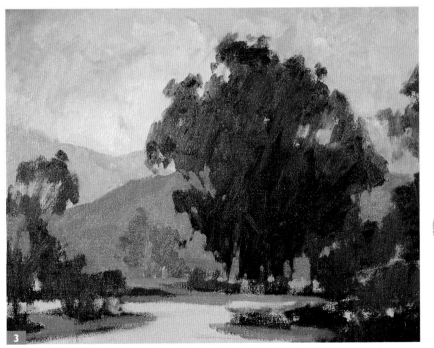

Step Three I block in the mountain directly behind the tree with a mix of white, viridian green, cadmium red light, and yellow ochre. For the background, I want to show that the land recedes into the distance, so I use a cooler mix of white, cadmium yellow pale, phthalo yellow-green, and touches of cadmium red light and cerulean blue. The banks of the bay have more cadmium red light and cerulean with a touch of yellow ochre. Because the eye is drawn to brighter colors and warm colors "pop" forward, I warm the colors around the large tree to draw attention to it.

29

Step Four I paint the left bank with a mix of white, cadmium yellow pale, cadmium red light, and cerulean blue, darkening the mix as I work downward. Then I lay in the reflections of the dark tree with horizontal strokes and a mix of ultramarine blue, viridian green, burnt sienna, and a little yellow ochre. For the sky's reflection, I mix white, cobalt blue, yellow ochre, and cadmium red light, gently blending the light and dark colors together.

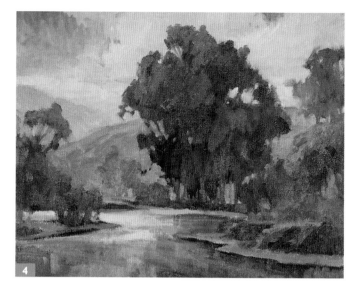

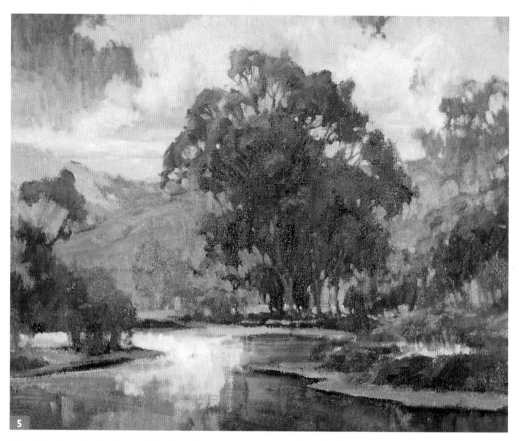

Step Five I was inspired to paint this sky by the stormy weather condition that formed magnificent clouds in a crystal clear atmosphere; the colors seemed to pop out of the sky! I took some "artistic license" here and incorporated some of that excitement into the blue sky. I start by applying more color in the upper sky, using vertical strokes to mirror the vertical strokes in the water. I use basically the same colors I used in step 2 but with fewer grays and whites. I make the blue sky darkest at the top, lightening and warming it toward the horizon.

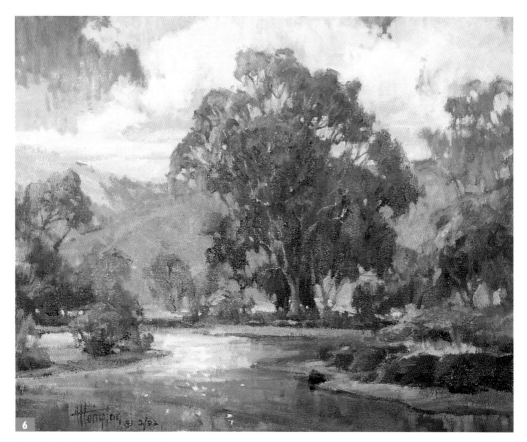

Step Six I add the lightest areas of the trees with varying mixes of white, yellow ochre, phthalo yellow-green, cadmium red light, and cerulean blue. I add more highlights to all the foliage with mixes of white, viridian green, yellow ochre, burnt sienna, cadmium red light, cadmium yellow pale, and ultramarine blue. For the highlights on the mountains, I brighten the colors by adding white to a mix of cadmium yellow pale, cerulean blue, and a touch of quinacridone rose. With moderate pressure on the brush, I paint over the water with a few horizontal strokes of cad. red lt., blue-violet, and a touch of yellow ochre. (Painting horizontal strokes over still-wet vertical strokes is a quick way to create realistic bodies of still water.) Next I add some final details to the large tree trunk using dabs of a mix of burnt sienna, ultramarine blue, and yellow ochre. I add a few touches of color to the outlying areas, but am careful not to create too much detail there, as it will take away from my center of interest. I use a mix of ultramarine blue, burnt sienna, and viridian green for dark accents in the large tree and outlying foliage.

Positioning the Horizon Line for Good Composition

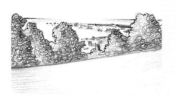

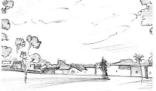

Good Format: High Horizon

Think of landscapes as divided into three parts. Here the horizon line is set on the upper third of the composition, making the foreground and middle ground stand out.

Good Format: Low Horizon

A low horizon emphasizes the sky or large objects in the background. Here the sky is dominant and a diagonal visual path leads from the foreground to the houses on the horizon.

Bad Format: Centered Horizon

With the focal point in the center, this composition is boring. There are no visual devices to lead the viewer's eye around the landscape, so the scene looks flat.

31

Lesson 5: Painting Portraits

with Anita Hampton

Painting people is just like painting anything else; a human face has basic shapes and contours just like a landscape or an apple. Facial features catch light and create shadow patterns just as features of other objects do. The key to portraiture is noticing the subtle differences in the features of each individual, such as a wider nose, thinner lips, or a higher or lower forehead. Draw what you really see and your portrait will look like your model. For this portrait, Anita Hampton paid careful attention to the relationship between her model's eyes, nose, and mouth, as children's facial features are usually closer together than those of adults.

Color Palette

burnt sienna, cadmium orange, cadmium red light, cadmium yellow deep, cadmium yellow light, cerulean blue, cobalt blue, quinacridone rose, titanium white, ultramarine blue, viridian green, yellow ochre

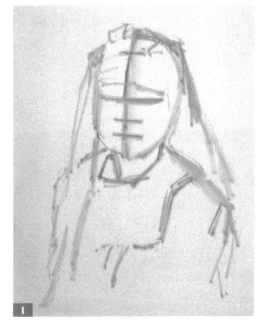

Reference Photos Painting portraits in oil can take many hours, even days. Most children have a hard time sitting still for this long. Although a photo can't compare to a live subject posing for you, take photos of the children you wish to paint. That way you can take your time with the portrait.

Step One I sketch with a small round bristle brush and yellow ochre paint—a weak, nonstaining color. I want to emphasize my model's beautiful hair, so I sketch the head and shoulders first. I create some basic guidelines that serve as a map for placing the facial features. For the slightly tilted angle of her face, I draw a curved center vertical line. Then I create the central horizontal line through the middle of the vertical line. Because Audrey is a small child, her eyes, nose, and mouth all fall below this line. Below the eyeline, I add two more horizontal lines to position the base of the nose and the center of the mouth, making sure my lines are parallel to each other and perpendicular to the vertical line.

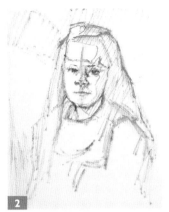

Step Two Now I draw in her facial features with burnt sienna and a clean round brush, keeping the paint fairly dry to make clean, crisp lines. If I need to remove a portion of the drawing, I dip a paper towel in solvent and lift off the unwanted paint. Next I indicate the hairline on the forehead and draw the sides of the face. I block in the shadows with pure cerulean blue, using parallel, *hatch* lines to keep the basic shadows clear and defined. I'll use these lines later as guides.

Lights in Hair

white

+ cad. yellow pale

+ yellow ochre

+ cad. yellow deep

+ cad. red light

+ cerulean

+ cad. yellow pale

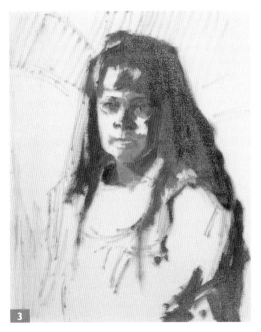

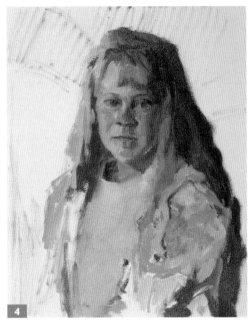

Step Three Now I lay in the darkest values in the hair with a mix of burnt sienna, viridian green, yellow ochre, and a touch of cadmium orange. To create contrast within this large, dark shape, I separately apply touches of each color from the mix. For the lighter shadows, I lighten the mix with yellow ochre and cadmium yellow deep. For the shadows around the eyes, I use a medium filbert and a mix of burnt sienna, viridian green, cadmium orange, and a small amount of yellow ochre, adding separate touches of each color to create variation within the shadowed skin tones. Then I add the small shadow on the left sleeve with a mix of cobalt blue, quinacridone rose, and a little yellow ochre, twirling the brush in a loose, swirling motion that mimics the fabric patterns.

Step Four Next I add the lights in the hair with a medium bristle brush and a thick mixture of white, yellow ochre, cadmium red light, and a small amount of cerulean blue. I use large, wide strokes and add touches of the original color mixture over the light hair to keep it from looking like a flat surface of plain, solid color. With a mixture of white, cadmium yellow deep, cadmium red light, and a touch of cerulean blue, I block in the light bodice of the dress. I make this value slightly darker than it appears, as I'll be applying the lighter embroidery over it. Using a variety of color mixtures, I roughly block in the floral print of the dress. I'm always tempted to work on details right away, but adding details too soon can make subjects look cluttered and cause colors to conflict with each other. So, at first, I paint as loosely as possible.

Step Five I accent Audrey's light blond hair by adding a dark gray background of ultramarine blue, burnt sienna, yellow ochre, and a little thinner. For the lighter areas, I add more yellow ochre to the mix. I let the background blend with the hair, pulling the brush with light linear strokes to create soft edges; tight, unblended edges can make a figure look as if it is pasted on the canvas. While the paint is still wet, I add more highlights to the hair with a small flat brush. Again, I work some of the paint into the background to create a loose, natural texture.

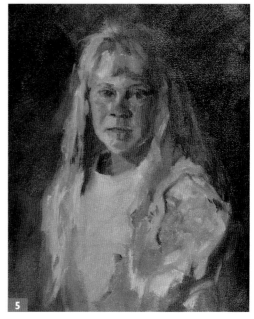

Light Skin Tones

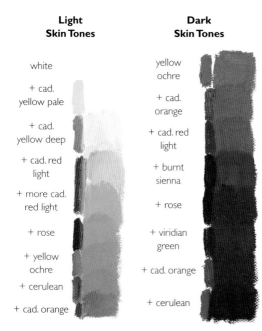

white

+ cad. yellow pale

+ cad. yellow deep

+ cad. red light

+ more cad. red light

+ rose

+ yellow ochre

+ cerulean

+ cad. orange

Dark Skin Tones

yellow ochre

+ cad. orange

+ cad. red light

+ burnt sienna

+ rose

+ viridian green

+ cad. orange

+ cerulean

Eyes

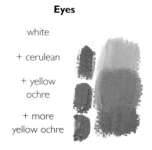

white

+ cerulean

+ yellow ochre

+ more yellow ochre

Step Six Now I build up the skin tones with cadmium red light on the cheeks and chin and a mix of white, cadmium red light, and a little yellow ochre, softening the edges with a large flat sable brush. For the skin's soft texture, I use a dry sable brush to smooth the paint and soften the edges. Now I develop the details of the organdy dress, bringing out the pale embroidered shapes with a mixture of white, cadmium yellow light, cadmium red light, and a touch of cerulean blue. Then I apply a lighter shade of this mixture with a small flat sable brush and feathery strokes. Because I want Audrey's hair and eyes to command the most attention, I simplify the dress fabric, making it a muted version of what I actually see. I develop the eyes with the colors shown above and then I build up the hair with several thick brushstrokes, so I can add more highlights and draw the viewer's attention to it.

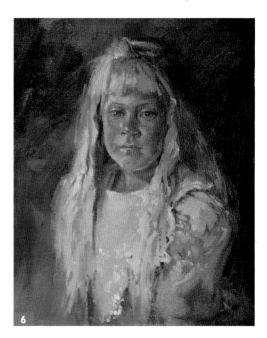

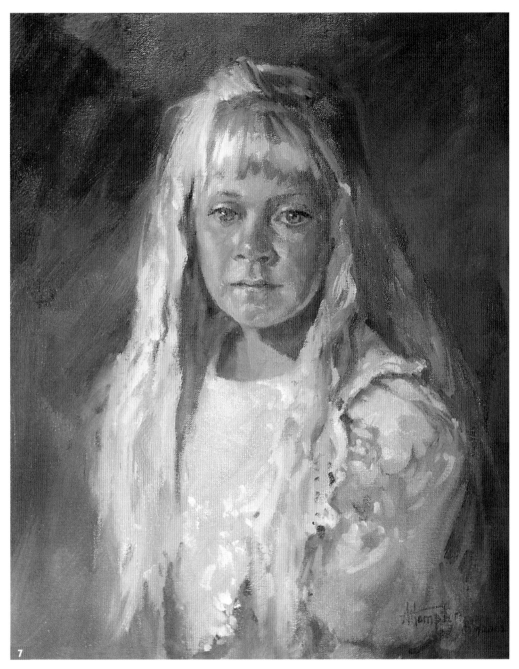

Step Seven At this stage, I like to view my paintings in a mirror, which gives me a fresh view of my work and helps me spot areas that may need minor changes. I find I need to lower Audrey's right shoulder and darken the right side of her face. I darken the skin slightly, as I'd added too much white to the mixture. Finally, I raise the right corner of her mouth slightly, simplify the light shapes on her left sleeve, and add more detail to her left eye with a few final highlights.

Lesson 6: Setting up a Still Life
with Anita Hampton

Painting still lifes is an age-old artistic practice that is great for studying composition and light. Like a landscape, a still life composition should have a visual path that leads your eye in and around the painting as well as a distinct center of interest. However, unlike a landscape, you're in control of choosing the objects in the scene and the type and direction of the light source. When setting up a still life, experiment with lighting, as this can make all the difference in whether a scene is lively and dynamic or flat and dull. Moreover, to add interest and variation to your still lifes, choose objects of different shapes, colors, and textures. For example, in this still life, artist Anita Hampton chose to contrast the bulbous shapes of roses and apples with a cylindrical vase and a somewhat square, vertical candle.

Color Palette

cadmium orange, cadmium red light, cadmium yellow light, cerulean blue, cobalt blue, Indian yellow*, phthalo yellow-green*, quinacridone rose, sap green, titanium white, transparent oxide red*, Venetian red*, yellow ochre

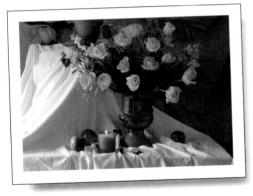

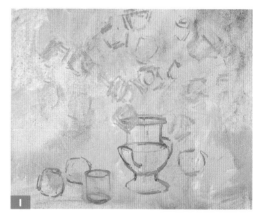

Choosing a Light Source Natural light (such as light from a north window) is much cooler than artificial light (such as light from a lamp or studio light). Here I chose to use both because I like the lively contrast between the cooler natural light from a window to the left of the scene and the warmer hues created by a studio light on the right.

Step One Once I'm happy with my setup, I lay in a thin wash of Indian yellow with a large bristle brush. Then I add a touch of quinacridone rose and apply the color liberally with broad stokes to quickly cover the canvas. For the edges, I create a thin mix of quinacridone rose and cobalt blue. I establish the cooler hues on the right by adding more blue to the mix. For the warmer hues in the flower area, I add more quinacridone rose. To avoid harsh color changes, I gently blend the edges of these washes with a paper towel. Then I block in the basic shapes of my composition with a mix of sap green, cadmium orange, and cadmium red light.

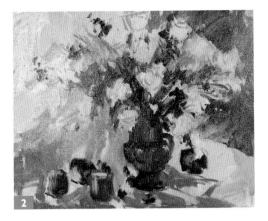

Step Two Now, starting with the green leaves, I block in the darkest values with a mixture of sap green, transparent oxide red, and cobalt blue. I use a medium filbert to create soft, blended edges. I further develop the darkest values with varying mixes of a little phthalo yellow-green, rose, cadmium red light, and cobalt blue added to the original green mixture. The vase has more red with only a little green, and the leaves have more green with only a little red. For the apples, I mix rose, transparent oxide red, and phthalo yellow-green. Next I block in the shadows on the cloth with a mix of white, cobalt blue, and transparent oxide red. I want the cloth to have rich variation, so I create several shades of this mix by adding varying amounts of cadmium red light, cerulean blue, yellow ochre, and cadmium orange. For the candleholder, I mix white, rose, cobalt blue, and a touch of yellow ochre.

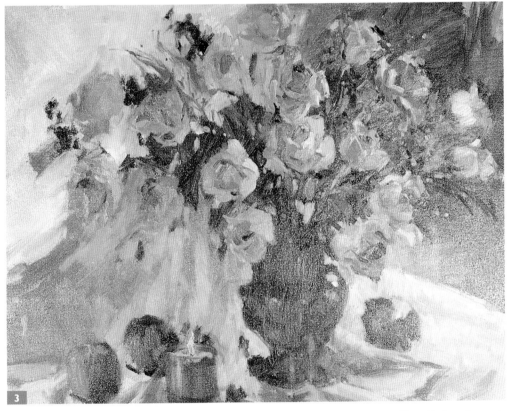

Step Three Now I paint the roses with a small flat brush and a basic mix of rose, transparent oxide red, Indian yellow, and a touch of phthalo yellow-green. For the flowers on the right, I warm the mix with cadmium red light or cadmium orange. For the flowers on the left I cool the mix with rose, cobalt blue, and a touch of white. For the warmest gray versions of the mix, I add a little cadmium yellow light, Indian yellow, or cadmium orange. Next I block in the light spots on the tablecloth around the vase with a mix of white, cobalt blue, transparent oxide red, and cadmium yellow light.

Step Four Now I add highlights, making the right side warmer and the left side cooler. I warm the petals on the right with different mixes of white, cadmium yellow light, cadmium orange, and a little cadmium red light. Then I mix rose, cobalt blue, and transparent oxide red into some of the shadowed petals in the center of each rose, blending the color with light strokes to soften any hard edges. For the highlights, I mix white, rose, and a touch of cobalt blue. I paint the leaves on the left with white, cobalt blue, and a touch of yellow ochre. For the warmer leaves on the right, I mix white, cadmium orange, phthalo yellow-green, sap green, and transparent oxide red. I paint the stems with a mixture of white, rose, cobalt blue, and a touch of yellow ochre.

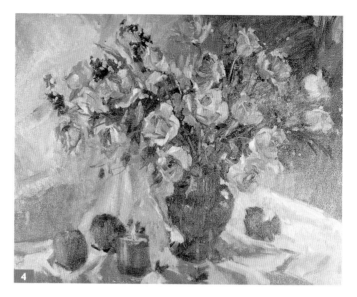

Candle Outer Flame

white, cad. yellow light, cad. orange, and cad. red light

Candle Inner Flame

white and cad. yellow light

Candle Wick

white, rose, and cerulean blue

Cool Flowers (Left)

base + rose and cad. orange

base + white, cerulean, rose, and cad. yellow light

base + white, cobalt blue, and rose

Flower Base (Center)

white, rose, transparent oxide red, and Indian yellow

Warm Flowers (Right)

base + white, cad. yellow light, and cad. orange

base + cad. orange + cad. red light

base + white, cad. red light, and cad. orange

Step Five I use a variety of gray mixes to develop the cloth and background. For the darker areas of the background and the folds in the tablecloth, I use mixes of cobalt blue, transparent oxide red, cadmium orange, phthalo yellow-green, and a little Venetian red. I add touches of lighter colors to the background with white, cobalt blue, rose, cadmium orange, and a little cadmium yellow light. Where the warm artificial light falls on the table, I add cadmium yellow light and cadmium orange.

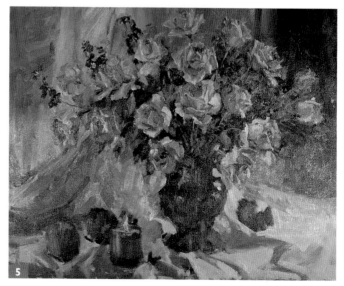

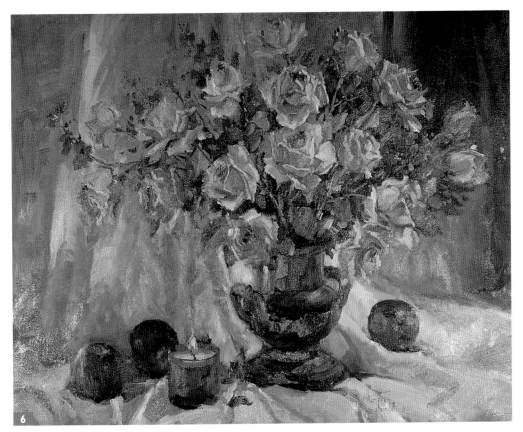

Step Six Now I add details to the apples. For the stems, I use a mix of yellow ochre, phthalo yellow-green, cobalt blue, and sap green. For the darker parts of the apples, I mix rose, transparent oxide red, and sap green. I touch up the stems with a mix of sap green, transparent oxide red, and cobalt blue. I paint the candleholder with a mix of white, rose, cobalt blue, and a touch of yellow ochre, warming the right side with a mixture of cadmium yellow light and cadmium orange. For the left side, I add more rose and cobalt blue to the mixture. For the flame's center, I create a thick mix of white and pure cadmium yellow light. For the darker area of the flame, I use a mix of white, cadmium yellow light, and cadmium orange, adding a touch of cadmium red light next to the yellow center. At the base of the flame, I complement the orange hue with a dark mix of white, rose, and cerulean blue. To create smoke, I add transparent oxide red and cobalt blue to the mix and brush this color upward from the tip of the flame. When I assess the painting, I decide to change the cloth folds. I want the background to have more linear, vertical shapes to counterbalance the round forms of the flowers.

**Leaf Base
(Center)**
sap green,
transparent oxide
red, and cobalt blue

**Cool Leaves
(Left)**

**Warm Leaves
(Right)**

base + white, yellow
ochre, and cobalt blue

base + white, cadmium orange,
and phthalo yellow-green

base + white, cobalt blue,
and sap green

base + white, Venetian
red, and sap green

base + sap green, and
cobalt blue

base + white, sap green, and
transparent oxide red

Lesson 7: Painting Doors & Windows

with Tom Swimm

Doorways and windows are a favorite subject among many artists and are great for experimenting with composition. They have a visual and philosophical appeal, and evoke a sense of intrigue about what lies beyond them. Combined with other elements such as flowers and shadows, they can be colorful and compelling. They're basically two-dimensional, so the challenge is to bring contrast, depth, and interest to what could be viewed as a plain, flat, dull subject. Choose a doorway with a unique color, shape, or texture, and remember that the time of day is very important in creating mood and interest. For instance, in this painting, artist Tom Swimm experimented with the light of the early morning and late afternoon to find the most dramatic shadows and interesting plays of light.

Color Palette

alizarin crimson, blue-violet*, brilliant green*, brilliant yellow*, burnt sienna, cadmium orange, cadmium red light, yellow ochre, flesh*, Payne's gray*, phthalo violet*, Prussian blue*, sap green, titanium white

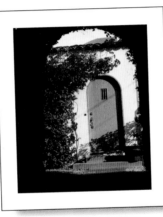

Selecting Your Photo I selected a photo that had bright colors and visual interest and cropped it in various ways to find a pleasing composition. I decided the foreground was too dark and not important to the scene, so I "zoomed in" on the doorway itself, eliminating the dull, distracting areas. I wanted to avoid placing the door in the exact center of the composition, so I set it to the right, which gave me room to include flowers on the left.

Step One I start with a light underpainting of yellow ochre, cadmium red light, and burnt sienna. I darken the mixture with sap green and then with alizarin crimson to block in the archway on the left with a large flat brush. I indicate the shadow across the door with a mix of Prussian blue and Payne's gray. I block in these main areas with very thin washes of color. I make the application thin enough that I can still see the drawing underneath, which will help me when I develop details.

Underpainting

yellow ochre, cadmium red light, and burnt sienna

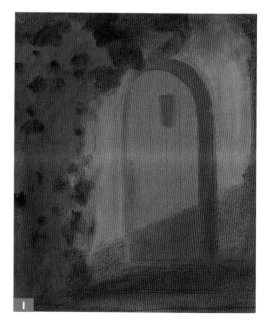

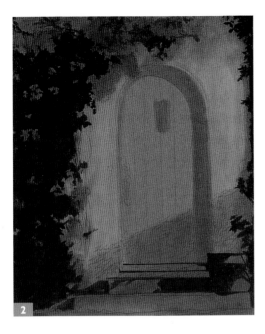

Step Two When working with oil paints, I like to work from dark to light, so I add the darkest colors to the painting at this stage. Using a medium flat brush, I apply a mixture of sap green and alizarin crimson to the leaves and the foreground shadows. Using the outline underneath as a guide, I'm actually drawing as I paint. I take a little extra care to define edges and shapes. To add interest, I leave some *negative space*, or blank space around the objects of the painting. To create the leaves, I use the flat side of the brush and make short, choppy brushstrokes, alternating the direction of each stroke. I use a dry brush to pull some color from the canvas and indicate breaks in the foliage, adding a sense of realism and depth.

Step Three Using Prussian blue mixed with Payne's gray, I paint the doorway shadow and small window opening, as well as the shadows cast by the door handle. Next I add a mix of phthalo violet and Payne's gray to the lacy shadows cast from the trees on the right. As with the leaves, I use a variety of brushstrokes and leave some "holes" in the shadows, which breaks them up and adds visual interest. Using yellow ochre mixed with burnt sienna and a little cadmium red light, I add the middle values of the front steps and foreground, along with some detail in the tree branches and door hardware. Then I define the flowers with the same dark red mixture.

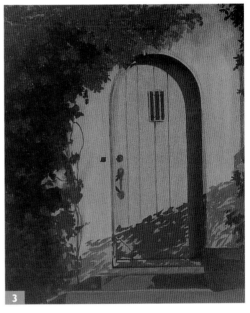

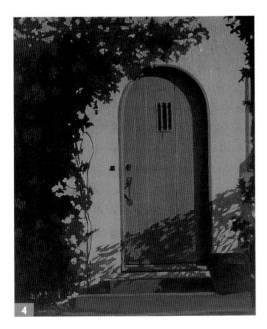

Doorway	**Wall**
blue-violet and flesh	flesh and white

Step Four This is where it starts to get fun and the painting comes to life! In this step, I add the last colors of the underpainting before applying the highlights. Using a mixture of blue-violet and flesh with a little white, I paint the surface of the doorway wherever it isn't shadowed. Then I paint the entire surface of the wall with a mix of flesh and a little white, using the negative spaces I'd created in the previous step as a guide. After covering the largest areas, I embellish some of the details, such as the vertical grooves in the door, with a slightly darker mix of blue-violet and flesh.

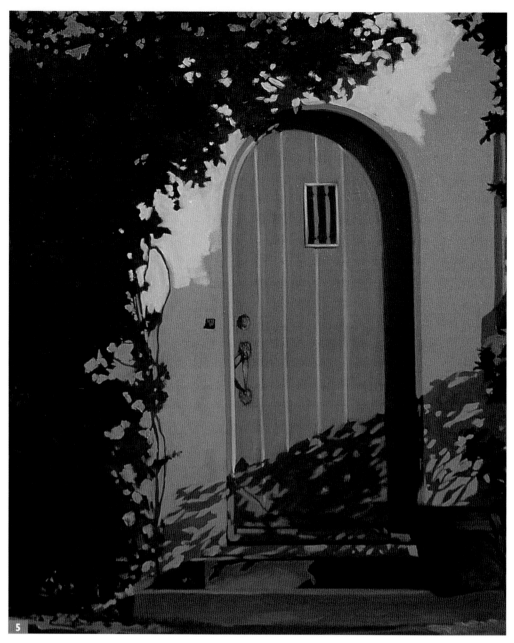

Step Five Using a mixture of flesh and white, I go back over the entire wall to punch up the lights. I load my brush more heavily with color now and vary the direction of the brushstrokes to add some texture. I also bring up the other highlighted areas in the door and the foreground. When I'm adding highlights, I like to paint loosely and let the brush do the work. I'm not concerned with trying to get a perfectly smooth, even surface. By varying the direction of the brushstrokes and the pressure, I create an illusion of dimension and reality. Flat, two-dimensional surfaces are boring in any painting, so be spontaneous. Paint boldly and have fun!

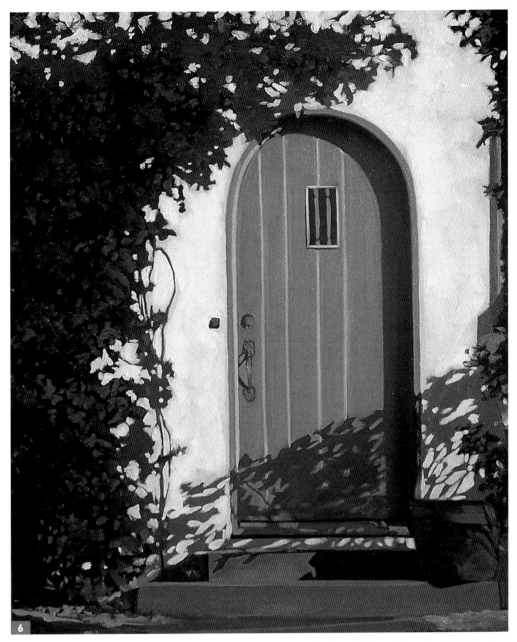

Step Six Now I add more interest and texture to the wall with a final application of brilliant yellow mixed with white. I also soften the highlights in the door by going over them with a dry brush. Using yellow ochre and cad. red light, I apply one more layer of color to the front steps and create some highlights with flesh and white. Once I'm satisfied with these final elements, all that remains is to bring life to the flowers and leaves. I bring out the color of the leaves by adding various green mixtures, starting with the darkest and working up to some final highlights. As with the door, it's important to stay loose and not try to cover the whole area. I paint around some of the dark areas to create the illusion of bright sun hitting the leaves. Finally I add the brightest flowers with a mix of cadmium red light and alizarin crimson for the bougainvillea and add a few touches of brilliant yellow and cadmium orange for the flowers on the right and the patch of grass in the foreground.

Lesson 8: Rendering Reflections

with Tom Swimm

Water is a great painting subject because it takes on so many forms—from the rushing white rapids of a river to the glasslike surface of a still pond. Generally, when rendering water in oil, use short, choppy strokes and thick paint to create rough waters and smooth, fluid strokes and thin color for calm waters. Also, remember that water reflects anything above its surface, including the sky; but the size, shape, and colors of the reflection will depend on the condition of the water. For example, in rough waters, an object's reflection will be wavy and broken, while in calm waters, the reflection will be a darker mirror image of the object. In this painting of a simple, single boat, Tom Swimm provides a perfect lesson in painting reflections. The surface of the water has small, gentle waves, so he used a combination of smooth, blended strokes and short, broken strokes. The boat's reflection is most fluid where it's closest to the actual boat. In contrast, the reflected rim of the boat (which is farther away) becomes rippled and the waves in the lines become more exaggerated.

Color Palette

alizarin crimson, brilliant yellow*, burnt sienna, cadmium red light, cerulean blue, flesh*, Payne's gray*, phthalo violet*, Prussian blue*, raw sienna*, sap green, viridian green, white, yellow ochre

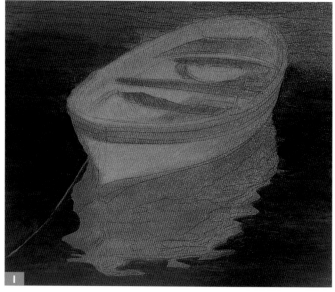

Water

Prussian blue and viridian green

Prussian blue and cerulean blue

phthalo violet and Prussian blue

cerulean blue and viridian green

Step One Once I'm happy with my sketch, I start applying very thin washes with a large brush. First I block in the basic shapes of the boat and its reflection using a mixture of yellow ochre, alizarin crimson, and burnt sienna. I use very little pigment at this point, as I don't want to cover up my drawing, which I'll still need for reference. Then I add a little Payne's gray for the shadowed areas of the boat. Next I paint the water with various mixes of Prussian blue, viridian green, sap green, cerulean blue, and phthalo violet. When rendering water, I use fluid brushstrokes, meaning that I break up the thickness of the lines and vary their direction. At this stage, I want to cover the entire canvas with colors and values from the same families as the ones that will be used throughout the painting. I try to keep each of my paintings in "color harmony" by maintaining the same colors and mixtures that I started out using.

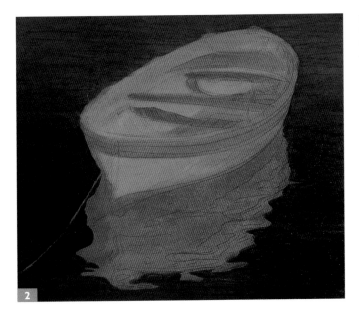

Step Two Now I develop the water by building up each of the values. Although the finished boat will be almost white, I use much darker colors for its reflection, mixing some of the colors I used for the water with the boat color mixture of yellow ochre, alizarin crimson, and burnt sienna. This creates a deeper blue version of the boat's color, which gives the illusion of depth and transparency.

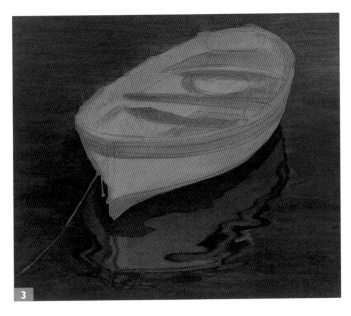

Step Three For the reflections of the hull, I add burnt sienna and raw sienna to the cerulean blue and viridian green mixture. Then I add a red tint to the shadows with a mixture of alizarin crimson, cadmium red light, and Payne's gray. Next I switch to a medium-sized flat brush and draw with the paint, adding dark, contrasting ripples. I create the reflected red stripes with alizarin crimson, cadmium red light, and Payne's gray. For the main part of the hull, I use a mixture of yellow ochre and alizarin crimson. Again I keep my brushstrokes fluid to convey the feeling of the boat floating on the water.

Hull	**Hull Reflections**
alizarin crimson and yellow ochre	raw sienna, burnt sienna, and cerulean blue

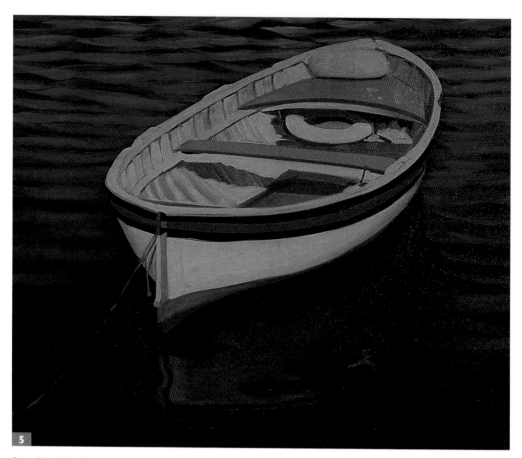

Step Five Now I paint the seats and the wood with a mixture of cadmium red light and flesh. Then I whiten the boat, loading a medium brush with a thick mix of white and brilliant yellow. I apply the paint liberally, varying the direction of my brushstrokes to create interest and texture. Accuracy is important, but I don't spend too much time on any one area; I don't want to overwork my colors. I let my brush do the work and try to create an impression of the details rather than painting photorealistically. A slightly unfinished look can actually give a painting more character than a perfectly realistic rendering.

Step Four Now I define the individual ripples in the water with four slightly different mixes from step one. I work from top to bottom, placing the lighter values toward the top, which heightens the realism of the water and adds depth and contrast to the painting. I also let some of the darker underpainting show through to give the waves more dimension. Next I add a thin coat of flesh over the sunlit areas and define the shadows with a mix of Payne's gray, flesh, and cerulean blue. I darken this mix for the two lines of trim on the outside of the hull. For the middle of the trim, I mix cadmium red light and Payne's gray and use minimal brushstrokes to give the lines a smooth, uninterrupted look.

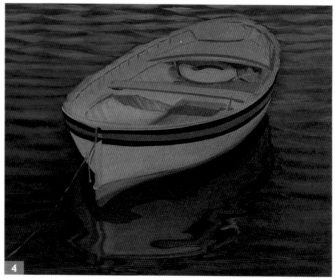

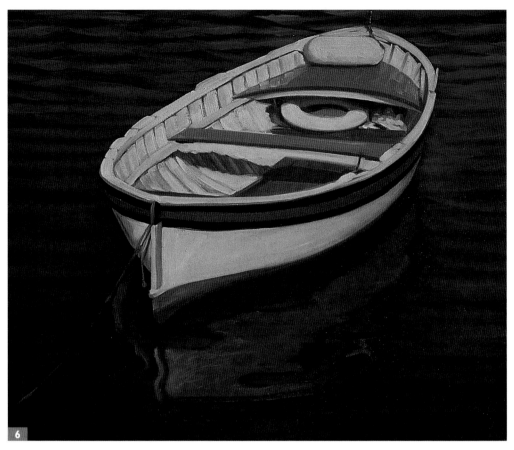

Step Six I continue building up the white of the boat. Then I make a few adjustments, adding lighter reflections to the hull in the water and defining the elements inside the boat and on the wood trim. Finally I touch up the rope and add a few more highlights to the water at the top of the painting.

Painting Reflections in Moving Water

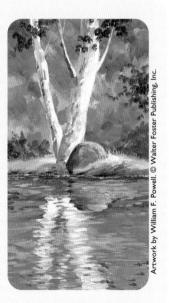

The more movement there is in water, the more distorted an object's reflection will become. Moving water causes a reflection to become elongated and to have blurred edges. When painting reflections, try to keep it simple. In fact, if your rendering of a reflection in moving water is too complex, it will actually look less realistic than a loosely painted "suggested" reflection. As a finishing touch, add mottled dabs of color to indicate the patterns of light on the water's ripples.

Lesson 9: Simplifying a Scene

with Tom Swimm

Street scenes are an enticing subject with their variations of color, shape, and texture, but they might appear intimidating to some artists. There are a few things to keep in mind that will help you simplify a complicated scene. First, focus on the basic colors and shapes. Too many details will make a scene overly busy and less intimate. Second, try to "suggest" elements with just a few brushstrokes; don't worry about painting every leaf on a tree or every shingle on a roof. To see the main shapes and ignore the details, try squinting, as you observe. Finally, stay focused on what first enticed you to paint a scene; don't get distracted! In this street scene, Tom Swimm liked the bright colors and shapes of the buildings and the steepness of the hillside, so he concentrated on these elements and was able to naturally simplify the scene.

Color Palette

alizarin crimson, blue-violet*, brilliant green*, brilliant yellow*, burnt sienna, cadmium red light, cadmium yellow light, cerulean blue, flesh*, Payne's gray*, Prussian blue*, sap green, viridian green, white, yellow ochre

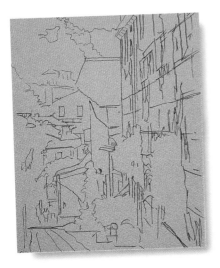

Outlining shapes I begin with a rough drawing, outlining the basic shapes with a fine-point marker. At this stage, I'm concentrating on making sure the perspective and proportions are correct; I'll add the details when I paint.

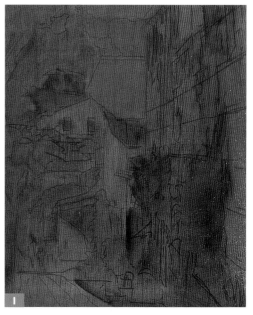

Step One Once I'm happy with my sketch, I apply the first layer of paint in thin washes to establish the basic relationship of colors and values. With a large brush, I use colors straight out of the tube, starting with cerulean blue for the sky, background hills, street, and one building. I use sap green for the foliage and mix burnt sienna and yellow ochre for the remaining buildings. To define some of the shadowed areas, I apply a little Payne's gray.

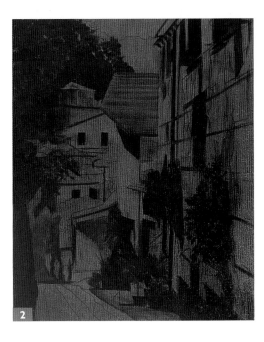

Step Two Now I add the darkest values. Using a medium flat brush and a mixture of Prussian blue, sap green, and alizarin crimson, I paint the dark foliage and define the dark shapes of the windows and shadows in the buildings. I avoid using black in my paintings, as I feel it brings a harsh, artificial tone that does not really exist in nature. Experiment with mixing color, and you'll find you can vary the hue of even the darkest areas in your paintings without ever using black. Next I add some more color to the roof in the center of the scene with a mix of yellow ochre and Payne's gray, varying the direction of my strokes to create interesting textures.

Shadows

Prussian blue, sap green, and alizarin crimson

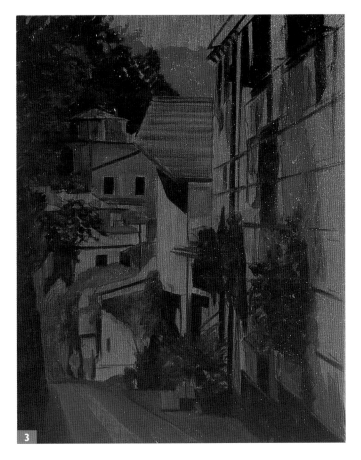

Step Three Here I bring out the middle values with stronger color and thicker paint. I use variations of a blue-violet and Payne's gray mixture for the hillside, the building in the center, the street, and the shadows on the wall on the right. I also add some middle values of the same mixtures to the foliage, the vines growing on the roof of one of the buildings, and the trees in the background.

**Hillside,
Building, and
Street**

blue-violet and
Payne's gray

49

Buildings

flesh and
yellow ochre

cadmium red
light and yellow
ochre

Step Four Once the darks and middle values of the underpainting are complete, I'm ready to enliven the scene. I load the brush with the color flesh and work on the large wall of the building on the right, painting around the shadows and some of the architectural details. Using a combination of flesh and yellow ochre, I add highlights to the yellow buildings. For the darker buildings and some of the rooftops, I use the blue-gray mixture from step three. Then I apply a mixture of cadmium red light and yellow ochre to the building at the bottom center. It's important to have fun and let the brush do the work from this point on. Although I do need a certain degree of accuracy, I try not to spend too much time on any particular area.

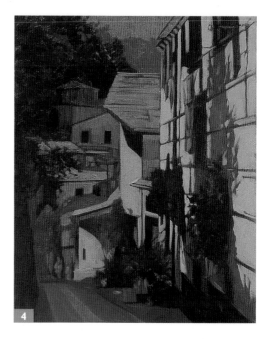

Step Five For the plants and foliage, I apply a variety of green mixtures (see color mixtures below), varying the direction of my brushstrokes and painting around the dark areas that I already established in my underpainting. At this stage, the scene should have a feeling of true dimension and depth.

Foliage

brilliant green
and yellow
ochre

brilliant green
and blue-violet

sap green
and flesh

sap green and
yellow ochre

sap green and
cad. yellow light

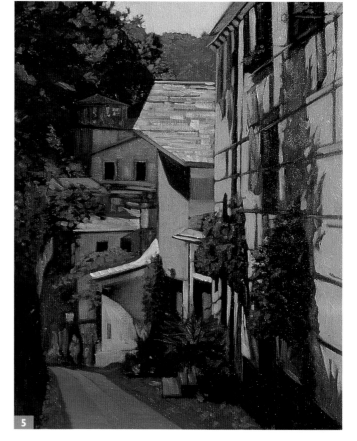

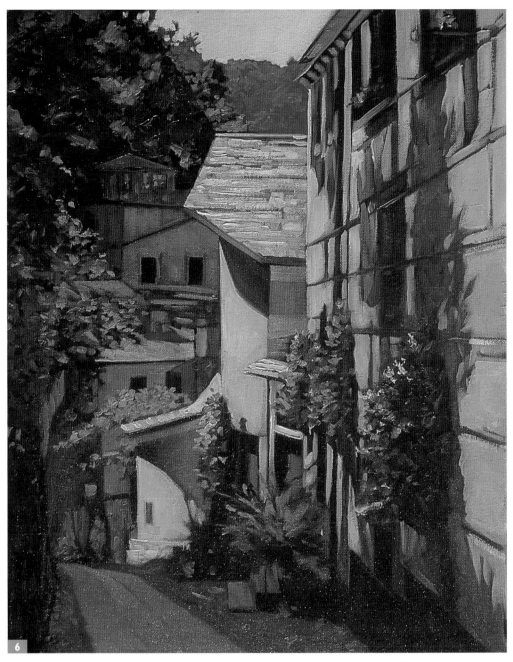

Step Six I step back and take a look at what I've completed so far and decide what I need to adjust. I want the sky to have a hazy feeling to heighten the contrast in the buildings, so I mix white with a little flesh color and blue-violet. I create the brightest highlights on the rooftops with a mixture of white and brilliant yellow. To add a sense of texture and realism, I keep my brushstrokes loose. I mix cadmium yellow light and white for the final highlights on the yellow buildings. I also apply this color to some areas of the wall on the right for interest. I bring up the lighter values of color in the other buildings and then add highlights to the foliage using sap green mixed with cadmium yellow light and viridian green mixed with yellow ochre.

Lesson 10: Building Vibrant Colors

with Caroline Zimmermann

Although the traditional approach to underpainting is to use hues similar to the color of your subject, you can also achieve unique, incredible results by doing just the opposite! Artist Caroline Zimmermann uses vibrant hues in her underpaintings to create a luminous surface of dazzling color. Because she usually paints outdoor scenes, she begins her paintings by covering the canvas with warm oranges and reds to contrast with the blues, greens, and grays of nature. Although these colors may not appear in her final paintings, their subtle radiance shows through the top layers of paint; the reds actually intensify the subsequent layers of paint on the canvas. Try toning your canvas with this type of underpainting, using colors that may not even exist in the scene you're rendering. You'll be amazed by the beautiful effects these hues help you achieve!

Color Palette

alizarin crimson, cadmium yellow light, cadmium yellow medium, dioxazine purple*, Indian yellow*, lemon yellow, magenta, phthalo blue, phthalo green*, quinacridone pink*, sap green, titanium white, transparent orange*, ultramarine blue

Foliage

sap green and lemon yellow

sap green and alizarin crimson

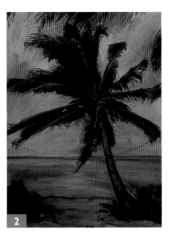

Step One To create an underpainting that will contrast beautifully with the greens and blues of this tropical scene, I use a mix of alizarin crimson, dioxazine purple, Indian yellow, transparent orange, and magenta. I thin the mixture with turpentine so it will spread easily over the canvas and apply the wash with a medium brush. I will be dedicating the top 2/3 of the canvas to the sky, so I decide to add more orange in the sky area, because orange is the pure complement of blue. I do this with a mix of Indian yellow, transparent orange, and quinacridone pink. Then I let the paint dry before continuing to the next step.

Step Two First I mix alizarin crimson with a little dioxazine purple and a few drops of solvent. Then using a medium bright brush, I sketch the composition, establishing the horizon and the lines of the palm tree's trunk. I make dots where I will place the ends of the leaves and connect the dots to create the palm's shape. I finish blocking in my basic shapes by adding more purple to the crimson mixture and designating the darker areas of the trunk, the leaves in the bushes, and the shadows below the tree. (To create the palm leaves, see the detail on page 54.)

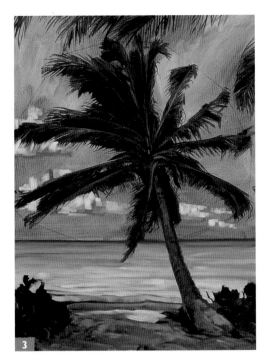

Step Three The color of the water changes as the depth changes, becoming darker as the water gets deeper. I begin with the darkest areas of water at the horizon, using broad strokes of ultramarine blue with dabs of phthalo blue and phthalo green. I work toward the shore, mixing in tints of phthalo blue and green and gradually adding white as the water becomes more shallow. I keep lightening the mixture until there is very little green pigment left, and I add a touch of lemon yellow for the shallowest areas. I paint the sand and any bits of flotsam on the beach with white mixed with transparent orange, Indian yellow, and dioxazine purple. I add dark colors to the foliage of the shrubs with a mixture of ultramarine blue, dioxazine purple, and sap green. I block in the dark parts of the clouds with a mixture of dioxazine purple, ultramarine blue, and a little white, and then I outline the general cloud shapes. I don't emphasize them too much as they're merely the backdrop, and I don't want them to conflict with my main subject.

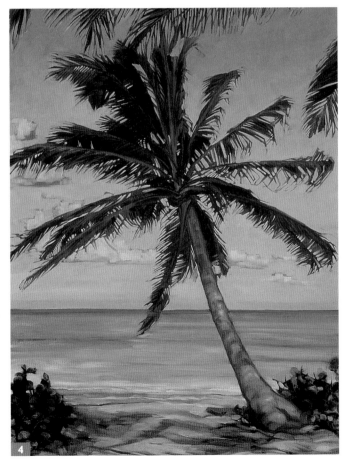

Step Four Now I block in the colors of the sky. I mix one part ultramarine blue to three parts white and just a dab of phthalo blue. When painting the sky, I "cut in" around the palm leaves, meaning that I create the shapes of the leaves by painting the sky around and between them. (This technique is called "negative painting," because you define an object by painting the negative space around it rather than painting the object itself.) Next I add more variation to the color of the water using light blue mixtures of phthalo green and phthalo blue. For the shallowest water, I use white mixed with a dab of dioxazine purple and Indian yellow. Then I add a bit more yellow and orange to the white and develop the highlights on the sand. I paint the dark areas of the palm leaves with sap green mixed with alizarin crimson and allow the painting to dry before I continue to the next stage.

Step Five Now I focus on the palm tree. I concentrate on showing the motion the wind creates as it blows through the leaves. I follow the steps outlined below to develop the palm fronds and then paint the center of the tree, making my strokes follow the round shape of the trunk. I paint the coconuts and the texture of the trunk with mixtures of dioxazine purple, transparent orange, and some of the green mixtures of detail step 4.

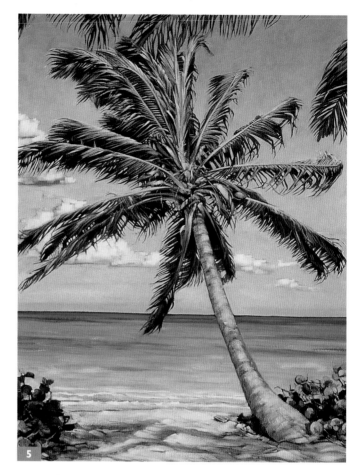

Painting the Palm Leaves

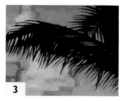

Step One While the paint is wet, I block in the palm leaves by removing paint instead of adding it. To do this, I clean my brush with solvent, blot it on a rag, and lift the color away to indicate where the highlights will be. This is a forgiving technique for indicating lighter areas without the mess of adding white paint.

Step Two I create the shapes of the palm fronds by painting the sky and clouds in and around them, as described in step four on page 53. Then I use my small flat brush and short, deliberate strokes to create the tips of the leaves. I start at the center of the branch and stroke outward, lifting my brush at the end to create the sharp point.

Step Three Now I indicate the undersides of the palm leaves (in shadow) using a dark mixture of sap green and alizarin crimson. (I render each individual leaf with this color.) Then I paint the top sides of the leaves, continually adding more sap green until there is very little red pigment left in the mixture.

Step Four Next I add the highlights using sap green mixed with varying amounts of each yellow color in my palette, plus transparent orange and white. I alternate between dark and light to define the details of the branches. I bring the lightest whites of the clouds into the leaves with the same cutting technique I used before.

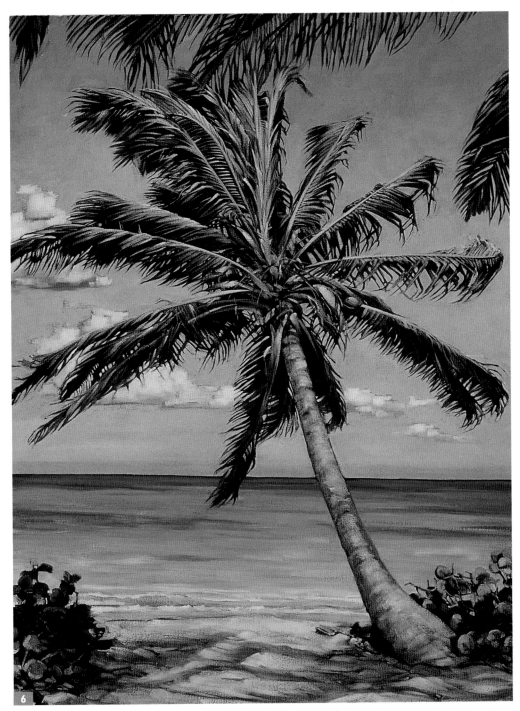

Step Six I apply the brightest highlights of the leaves, trunk, sand, water, and clouds at the very end of the painting so that these elements seem to shimmer in the tropical sunlight. I finish the painting by applying a glaze over the entire surface to unify the painting and adjust some of the colors. My goals are to deepen the top of the blue sky, tone down the red of the upper branches, and deepen the foreground shadows. So I prepare a glaze with a hint of ultramarine blue added to alkyd resin medium (a medium that speeds up the drying time of oil paints) and apply it to the upper areas and the foreground with a small brush. Then I coat the entire painting with a clear glaze of medium, rubbing away the excess with a flannel rag.

Lesson 11: Painting Animals

with Caroline Zimmermann

The key to painting animals is to capture the unique qualities of the subject, especially the animal's hair, fur, feathers, skin, or scales. There are countless ways of suggesting fur and feathers in a painting, and many of the techniques involve using special brushes that are made to mimic these textures. Other techniques include drybrushing, scraping, or spattering (see pages 12–13). As with any subject, creating a likeness simply requires careful observation—whether you're studying the actual creature or a photograph.

For this rooster, Caroline Zimmermann used different tools to create a variety of feather textures, from the soft, downy white in the tail to the crisp, shiny neck feathers. She rendered the highlights of the fuzzy feathers with flat bristle brushes and painted the crisp, shiny areas with acrylic flat brushes for more edge control. In addition, although she observed a specific pattern of coloration in the bird, because he's a living creature, she deliberately varied the pattern so he didn't look too perfect.

Color Palette

alizarin crimson, cadmium red medium, cadmium yellow light, cadmium yellow medium*, dioxazine purple*, Indian yellow*, lemon yellow, magenta*, phthalo green*, sap green, titanium white, transparent orange*, ultramarine blue

Step One To accent and create contrast with the greens and yellows of the rooster, I apply an underpainting using a mixture of alizarin crimson, dioxazine purple, Indian yellow, transparent orange, and magenta. I paint loosely and boldly with a large brush, eliminating the white of the canvas. I make the top portion of the canvas warmer and lighter and the lower half cooler and darker.

Step Two I sketch my composition with a medium bright and a thin mix of alizarin crimson and dioxazine purple. I work loosely and start developing the rooster's feather patterns. I want him to be proud and upright, with a billowing tail. As I build the rooster from a series of oval shapes, I pay attention to the relationship between the head and the rest of his body and try to capture the feeling of motion in his legs. To simplify the background, I make the wall out of rocks, and loosely indicate cracks and lines.

Step Three Next I develop the comb and the throat feathers with a medium flat brush, using a thin mixture of alizarin crimson, sap green, and magenta. Then, using a large flat brush, I work on the texture of the stucco wall, creating bits of stone and mortar and inventing patterns. I create my own brown mixtures using varied amounts of dioxazine purple, transparent orange, Indian yellow, and titanium white, scattering bits of rocks and sticks on the ground. I enjoy using my imagination, as it's a pleasant change from constantly referring religiously to the photograph. I let the paint dry long enough to "set," so that it's tacky (but not necessarily dry) and won't be easily smeared.

Step Four Using a large flat brush, I block in the darkest colors of the stones with a warm brown that I created from tints of purple and ultramarine blue mixed with transparent orange. I bring up the wall with white mixed with transparent orange, Indian yellow, cadmium yellow medium, and purple. I paint neck feathers (see color mixes on page 59) and block in the dark teal feathers with a mix of ultramarine blue and sap green. When I paint roosters or chickens, I use bold, wide brushstrokes and a lot of color to paint the feather.

Step Five Now I render the details, adding smaller stones near the base of his tail with lighter shades of purple. I apply highlights to the tail feathers and legs using various mixtures of phthalo green and white. I begin the eye with a dark mixture of alizarin crimson and transparent orange and paint the lighter area with a touch of cadmium yellow medium. I purposefully don't use "earth colors"—such as raw umber, burnt sienna, or ochres—because I like to create these tones by combining complementary colors with more vibrant pigments. For example, I use the complements of purples and blues—variations of yellow and orange—tinted with white to make vivid browns.

Step Six I place a tiny speck of white on the upper part of the pupil. This simple touch makes the eye come to life. I add a tint of cadmium red medium to the rooster's comb and use cadmium yellow light mixed with Indian yellow to accent the golden neck feathers and the tips of the back feathers. I mix phthalo green with lemon yellow tinted with white for the feet. To accentuate the rooster's rich colors, I make the background recede with a transparent glaze of alkyd resin, ultramarine blue, a touch of dioxazine purple, and sap green. I use a soft flannel rag to wipe away areas that are too dark. Then I apply a light coating of alkyd resin medium tinted with transparent orange. When the glaze dries, I bring out the highlights again and continue this process of adding layers of highlights until I'm satisfied. For the finishing touches, I tint the feathers with light brushstrokes of white. I use a smaller brush for the delicate, small feathers and the pieces of hay under his feet. With a medium flat brush, I create the farmyard dirt and stones with varied mixes of sap green, dioxazine purple, ultramarine blue, and a small amount of white, leaving the area under his feet dark to indicate shadows. Using vertical strokes to create texture, I go over the background again with a mixture of white and yellow.

Neck Feathers

transparent orange and cad. yellow medium

transparent orange and dioxazine purple

Tail Feathers

phthalo green and ultra. blue

phthalo green, lemon yellow, and white

Comb

cad. red medium and white

cad. red medium and alizarin crimson

Lesson 12: Expressing Mood

with Caroline Zimmermann

Any subject can be used to convey a mood or an idea. Although still lifes are most commonly regarded as subjects for studying form and shape, many artists enjoy creating drama in a seemingly ordinary scene filled with everyday objects. For example, in this painting of sunflowers and bread, Caroline Zimmermann uses a relatively dark palette and a low, dim light source so the objects cast long, dark cast shadows. This variation of light and shade is called "chiaroscuro," and it creates a dramatic, dusky feeling.

Color Palette

alizarin crimson, cadmium yellow light, cadmium yellow medium*, dioxazine purple*, Indian yellow*, lemon yellow, magenta*, phthalo blue, sap green, titanium white, transparent orange*, ultramarine blue

Step One For most underpaintings, I instinctively use the complementary colors of the subject to create the most visual intensity—for example, red for a green plant or orange for a blue sky. However, in this sunflower painting, I am using the reds of the underpainting not only to contrast, but also to create depth in the darks of the background surrounding the flowers. I covered the white of the canvas with a mixture of alizarin crimson, dioxazine purple, Indian yellow, transparent orange, and magenta, thinning each pigment with a few drops of solvent to create a fluid, transparent mixture.

Step Two I sketch the basic shapes with a combination of alizarin crimson and dioxazine purple mixed with solvent to create a fluid mix that lends itself to drawing with a brush. I create the general composition by drawing basic geometric shapes, keeping the definition to a minimum. Then I start blocking in the darkest areas, as shown.

Step Three Once I am satisfied with the general harmony of my composition, I draw the objects in greater detail. Using thinned alizarin crimson, I plot out the textures and patterns of the various elements. The better the drawing, the easier and more fun the later stages become as I apply the opaque paint. I compare this stage to the creation of a cake: I've measured my ingredients, mixed them, and now I am preparing to bake. The success of my creation begins here, and taking shortcuts can lead to messy and time-consuming mistakes.

Step Four I combine cadmium yellow medium with transparent orange and a dash of dioxazine purple to begin the sunflower petals, working from dark to light. I define my underpainting with opaque pigments, blocking in the colors with bold strokes and a large flat brush. For the greens of the leaves, I mix various values of sap green and lemon yellow. I create the fabric of the towel with a combination of ultramarine blue, phthalo blue, and white, applying the darkest values first. I paint the darkest shadowed areas with variations of ultramarine blue, dioxazine purple, sap green, and alizarin crimson. I also use various mixes of this "black" for the centers of the flowers, the candelabra, and the background shadows. I let the painting dry completely before applying glazes.

61

Step Five In this painting, the glazes play a major part in developing details and creating mood. I think of glazing as pushing and pulling the subjects of my painting in and out of the picture plane. For example, I think the yellows of the sunflowers are too bright and need to recede into the background, so I push them back with a glaze of alkyd resin, ultramarine blue, sap green, and a touch of dioxazine purple. I use a soft flannel rag to wipe out areas I want to pull forward, leaving other areas dark, such as the bowl, the shadows, and the wooden drawers in the background. When the glaze dries, I bring out the highlights again and continue glazing and highlighting, creating more luminous depth with each layer.

Painting the Sunflowers

Step One In many paintings of sunflowers, the flowers are placed in a bright, sunlit setting. But I want to tone them down in my painting to enhance the mood, so I begin with a very dark mixture of cadmium yellow medium, transparent orange, and dioxazine purple.

Step Two For the dark centers, I use a mixture of ultramarine blue, dioxazine purple, sap green, and alizarin crimson. I begin gradually lightening the petals with a mix of cadmium yellow light and transparent orange. This creates a rich, yet slightly lighter hue.

Step Three Now I've laid in my darkest values and I'm ready to build up the lighter colors of the petals. I touch each petal with a mixture of lemon yellow and Indian yellow, stroking in the direction of the growth—from the center outward to the distinct points of the petals.

Step Four Although I want my overall painting to be dark and moody, I still like the contrast of vivid highlights on the petals. This heightens the dramatic feeling of the painting. I add the final light touches to the petals with a slightly lighter version of the mix used in detail step 3.

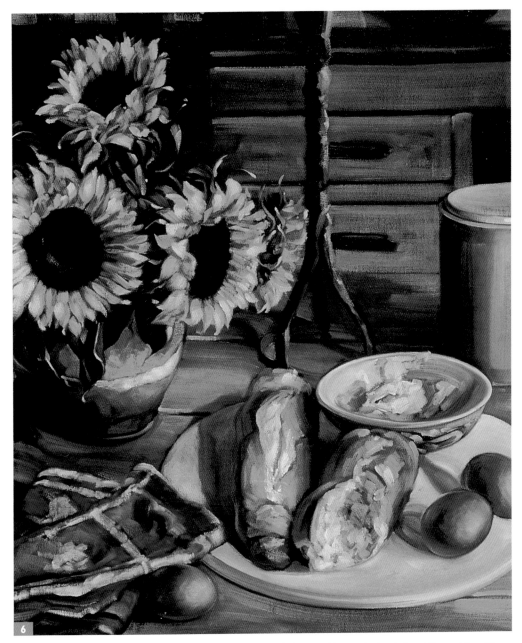

Step Six This is the step that I consider the most fun. I apply the brightest whites to the bowl, the platter, and the white crusts of bread. I add a subtle dab of white on each egg, the towel, and the canister to make the painting sparkle and give optimal depth. I add some final touches, applying a few more highlights to sharpen the foliage and flower petals.

Eggs and Bread Dark Values

transparent orange and
dioxazine purple

transparent orange and
cadmium yellow medium

Eggs and Bread Light Values

transparent orange and
lemon yellow

transparent orange
and white

63

Conclusion

We hope that you've enjoyed learning a variety of oil painting techniques from these four artists, and that this book will be a handy reference tool for you as you advance as a painter. Keep experimenting with tools, techniques, and color. Find what works for you, what inspires you, and what you really enjoy painting. A big part of being an artist is observing the world through an artist's eye: always looking for engaging scenes, interesting light, and unique subjects to paint. Begin your artist's morgue or start a sketchbook—and carry your camera with you to photograph whatever catches your eye. Most important, have fun!

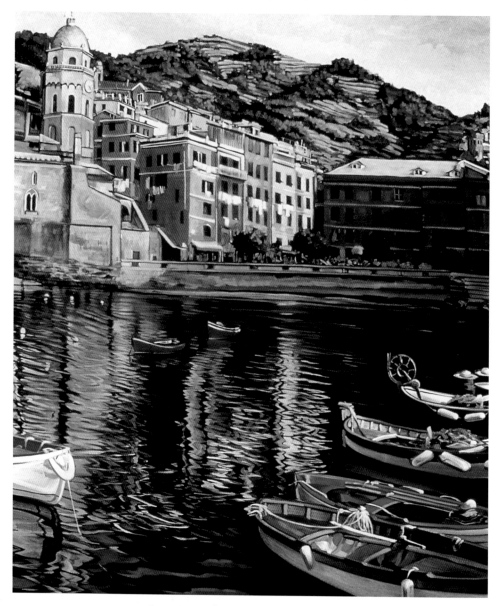

Cinque Terre by Caroline Zimmermann